CHATHAM

From Old Photographs

BRIAN JOYCE & SOPHIE MILLER

AMBERLEY

Acknowledgements

We would like to acknowledge the invaluable help given to us by the staff of Medway Archives and Local Studies Centre (MALSC). They include Alison Cable, Catharina Clement, Norma Crowe, Irina Fridman, Cindy O'Halloran, Nikki Pratt, Alison Thomas and Helen Worthy. Also, we would like to extend our special thanks to Phil Lewing for sharing his knowledge of Chatham Dockyard and Peter Bursey, Brian Gibson, Philip MacDougall and Max Tyler for kindly lending us photographs from their own collections. Every effort has been made to identify the copyright holders of the images in this book, the authors apologise for any accidental oversight.

First published 2014

Amberley Publishing
The Hill, Stroud
Gloucestershire, GL5 4EP

www.amberley-books.com

Copyright © Brian Joyce & Sophie Miller, 2014

The right of Brian Joyce & Sophie Miller to be identified as the Authors
of this work has been asserted in accordance with the
Copyrights, Designs and Patents Act 1988.

British Library Cataloguing in Publication Data.

A catalogue record for this book is available from the British Library.

ISBN 978 1 4456 3291 9 (print)
ISBN 978 1 4456 3300 8 (ebook)

Typesetting and Origination by Amberley Publishing.
Printed in the UK.

Introduction

Throughout history Chatham has been visited and commented upon by various illustrious guests. Two of the earliest travellers, Celia Fiennes and Daniel Defoe, stopped in Chatham in the 1720s and remarked upon its Royal Naval Dockyard – impressive even then. This is where we start our tour.

Indeed, the town of Chatham owes its very existence to the dockyard. The town expanded as the dockyard expanded. Its economy, its social life and much of its landscape were dictated by the military and naval presence. A very masculine environment for many centuries, it was hardly a place for women to flourish. On the other hand, as both a naval and commercial port, the town has always attracted a diverse range of ethnic and religious groups.

Whereas towns in the industrial North of England could boast substantial buildings and parks donated by prominent businessmen, Chatham was what the newspapers called a 'government town'. Consequently, there was no entrepreneurial middle class to engage in such philanthropy here. The impressive architecture that does exist in Chatham is largely the work of George E. Bond – a local architect, who contributed much to the townscapes of Chatham and its neighbours.

We invite you to explore the development of Chatham from a small eighteenth-century community to a thriving Victorian town, with its dockyard, soldiers, sailors, teeming High Street, abundant businesses and the growing suburb of Luton. The twentieth century saw the town expand into the surrounding rural areas such as Walderslade.

We first arrive at Chatham by the most comfortable means before the railway era – the river, disembarking at the dockyard. We pass the Royal Naval Barracks – ignore the fact that most of the dockyard and barracks theoretically lie in the parish of Gillingham; they have always been known as Chatham Dockyard and Chatham Barracks. Both deserve our meticulous attention. We march towards Chatham town centre following the bend of the river, admiring landmarks on the way, and progress towards Sun Pier via The Paddock. We then meander along the west end of the High Street between Railway Street and the boundary with Rochester.

On our second outing to Chatham, we will try the latest novelty – the train. Having alighted at the station, we are faced with several choices of routes. Let's turn left first and explore the Fort Pitt area and Victoria Gardens. We then weave our way back to the station.

We now turn right and plunge straight into the hustle and bustle of central Chatham. Proceed down Railway Street and Military Road towards the Town Hall.

Having surveyed the building, we saunter back to the High Street to browse and shop in its 'Golden Mile' section. We may stop for refreshments in one of the many public houses en route. Having reached the Luton Arches, we turn and cautiously negotiate our way back via the notorious Brook district.

But perhaps you wish to avoid the hurly-burly of the High Street? Stroll along the New Road, examine the diverse architecture and proceed to the village of Luton – only a mile's walk from the Arches.

Alternatively, turn from the viaduct into Maidstone Road. Walk through suburban housing in the post-war Davis Estate and continue your constitutional to pre-war Walderslade. It is still rural, but you can already spot the signs of its transition into a suburb.

We are at the end of our walk. One more step and we'll leave Chatham, but we will reserve this for another day out. Enjoy your visit.

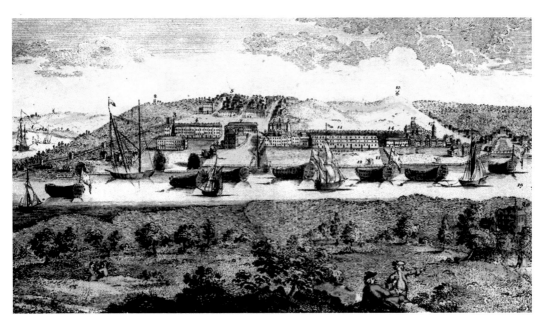

Prospect of Chatham
This mid-eighteenth-century engraving, which displays some artistic licence, shows Chatham Dockyard from Frindsbury. Brompton village is numbered five, and St Mary's church is seventeen. Hulks may be seen on the river. The two-masted vessel towards the left could be the naval pay office yacht, later used by John Dickens to sail between Chatham and Sheerness. Upberry Mill, numbered fifteen, overlooks the scene.

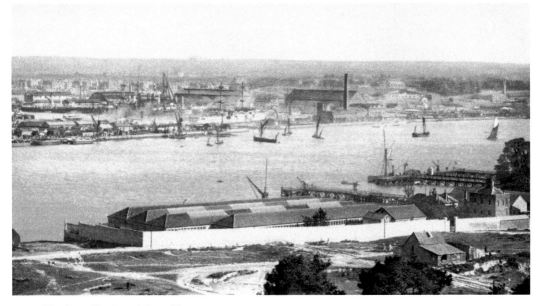

Chatham Dockyard from Upnor
The scale of the dockyard site may be appreciated from this photograph. The piers and establishments of the Royal Engineers in Lower Upnor are in the foreground. The pump house, workshops and other buildings of Chatham Dockyard itself stretch across the top of the picture.

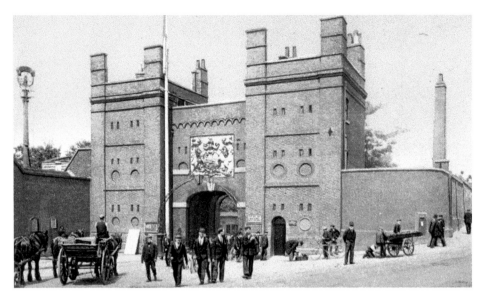

Dockyard Main Gate

The imposing main gate provided the finishing touch when a new high wall was constructed around the dockyard site in the early eighteenth century. It was completed in 1720, and the royal coat of arms was added in 1812. The two towers originally provided accommodation for dockyard officials. A notice on the right-hand tower warns workers not to bring matches into the yard. The hawker on the right may be selling tobacco. This gate doubled as the entrance to Wandsworth Prison in the film *Let Him Have It* (1991) and had been seen in the naval comedy *Watch Your Stern* (1960).

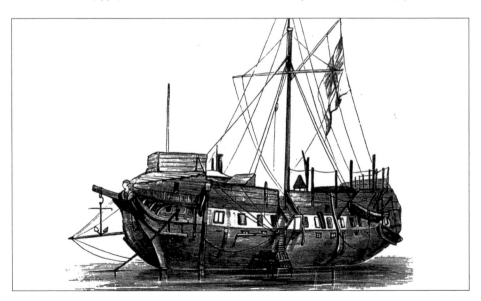

Convict Hulk

Obsolete warships, suitably modified, were a common sight on the River Medway. Some housed prisoners of war, others Royal Navy sailors. A further eight ships were used to house convicts at various times between 1822 and 1847. These men were used on different government construction projects in the area, including the dockyard extension from the 1860s onwards. By that time a purpose-built prison had replaced the hulks.

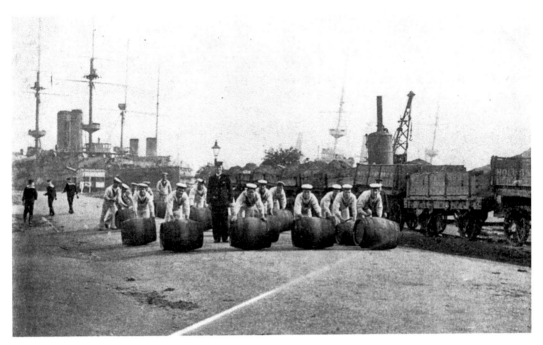

Rum Ration

The tradition of serving Royal Naval sailors with a daily ration of rum dated from the mid-seventeenth century. As time went on, it was progressively reduced in quantity and increasingly diluted. The tradition was finally abolished in 1970. In this Edwardian photograph, cheerful ratings are rolling casks bound for HMS *Pembroke*.

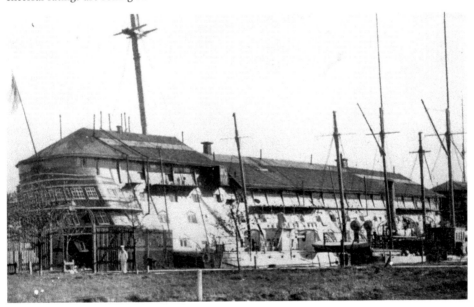

HMS *Pembroke*

This old warship, suitably adapted, was one of three hulks used to accommodate Chatham naval ratings before the opening of the Royal Naval Barracks in 1903. A number of smaller vessels, one of which is armed, may be seen alongside HMS *Pembroke*.

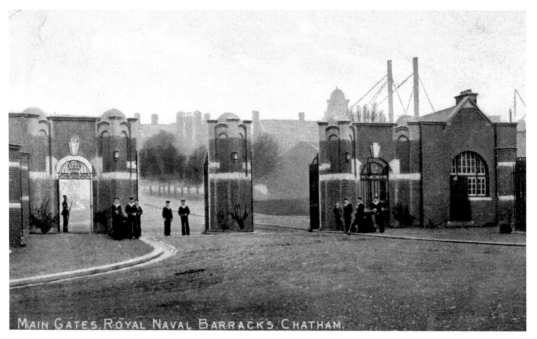

Naval Barracks Entrance
Sailors pose in front of the main gates of the newly built naval barracks. Opened in 1903, this vast complex was constructed on the site of the old convict prison. It, too, took the name HMS *Pembroke*. The entrance now provides access to the University of Greenwich Medway campus. It is still recognisable despite various modifications.

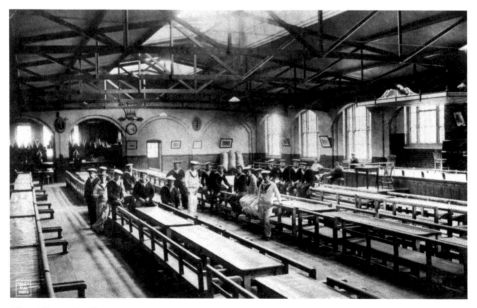

Naval Barracks Canteen
Edwardian ratings pose in the canteen of the newly constructed barracks. Notice the raised stage and piano on the right. The table on the dais is perhaps for the chairman who announced the performers and kept order during concerts.

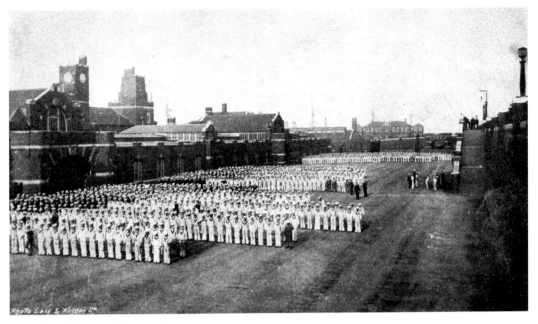

Naval Barracks Parade Ground
Today this space is used by the University of Greenwich Medway campus and is now more likely to be occupied by vehicles than people. The masts and funnels of warships in the dockyard may be seen in the distance in this Edwardian view.

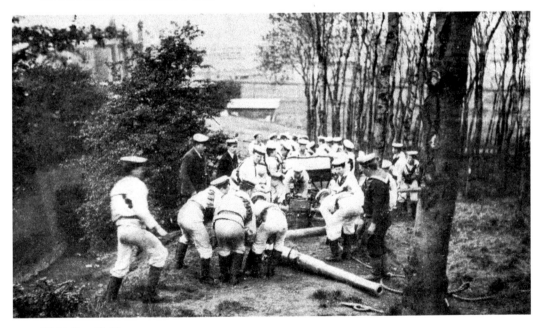

Field Gun Drill
Between the end of the Crimean War and the beginning of the First World War, the Royal Navy experienced little if any ship-to-ship conflict. However, sailors did see action on shore, so they needed to know how to assemble and dismantle field guns. When this Edwardian shot was taken, Naval Brigades had recently seen action in China and South Africa.

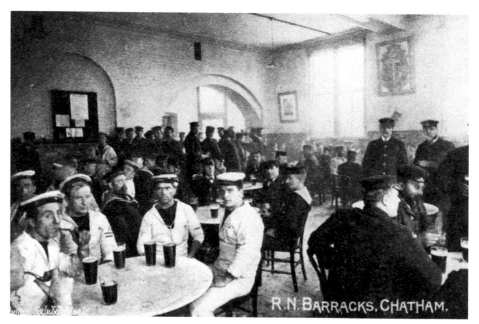

Naval Barracks – Petty Officers' Canteen
The canteen, while spartan by today's standards, was a great improvement on the facilities available before the construction of the barracks. Large windows provided plenty of natural light, augmented by electricity when necessary. Judging by the number of men enjoying their pipes and pints in this Edwardian photograph, the facility was extremely popular.

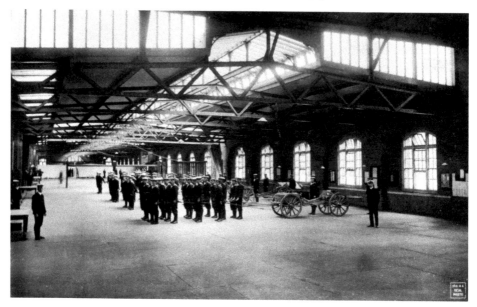

Naval Barracks Drill Shed
In September 1917, the drill shed was being used as sleeping accommodation for naval ratings. On the night of 3 September, German bombs crashed through the glass roof. Closely packed together in hammocks above the concrete floor, the sailors suffered appalling casualties. Today, the University of Greenwich's library occupies this building.

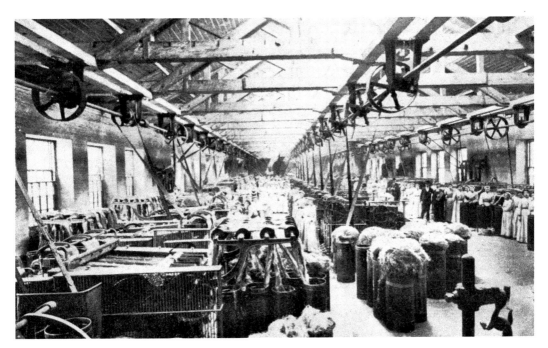

Dockyard Ropery
This Edwardian picture of the ropery reveals that it was one of the few departments of the dockyard that employed women. When recruiting for this department, preference was traditionally given to the widows of former dockyard workers, whose pensions had died with them. Today the ropery is still operational and may be visited as part of the Historic Dockyard tour.

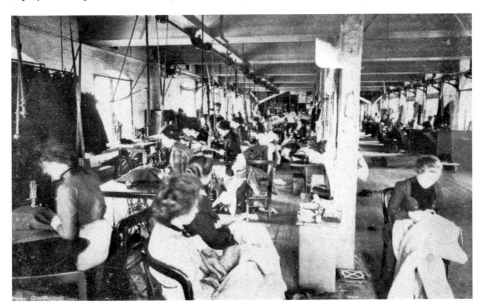

Colour Makers' Shop
Like the ropery, this shop was one of the few dockyard departments to employ women. Note the overhead drive shaft and drive belts. The women are making flags. The only man in this picture is probably a foreman.

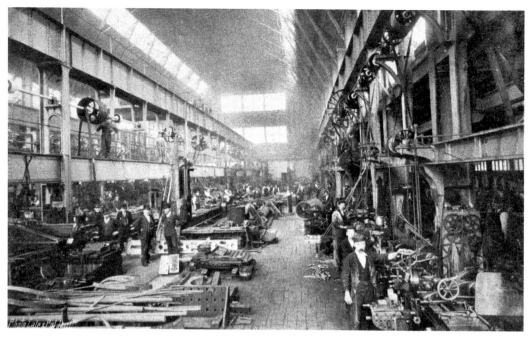

Dockyard Shipfitters' Shop
This Edwardian view features bowler-hatted foremen and cloth-capped workmen posing in their vast workplace. The height of this building is striking, as is the amount of natural light.

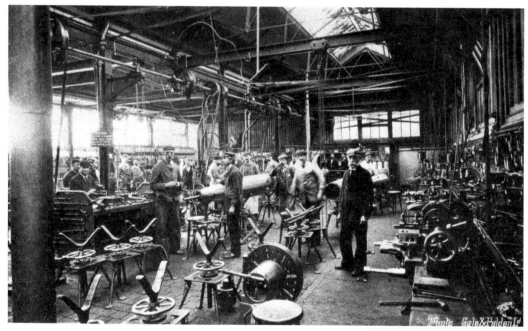

Dockyard Torpedo Fitting Shop
During the Victorian period, an increasing number of warships were fitted with torpedo tubes. From 1908, Chatham Dockyard began to build submarines – starting with C17 – thus increasing the amount of work undertaken in this shop.

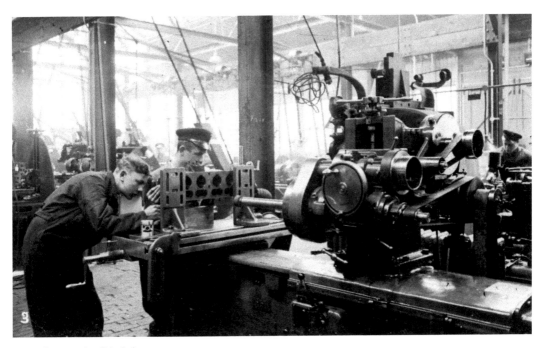

Apprentice Workshop
The young man on the left of the picture is probably a second-year apprentice working on a cylinder head in the early 1930s. The photograph was taken inside the apprentice workshop – the so-called 'Bottle Shop'.

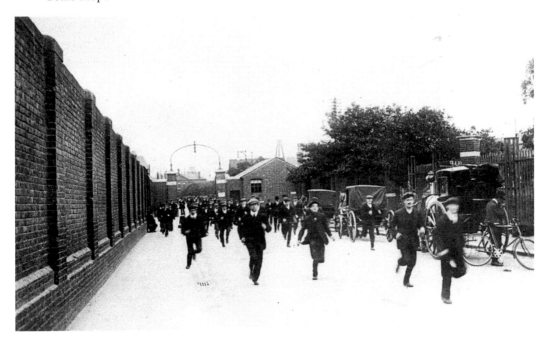

Dinner Time at the Dockyard
These dockyard workers are clearly keen to get to their main meal of the day, which in the Edwardian period was in the early afternoon. Note the horse-drawn cabs optimistically queuing on the right.

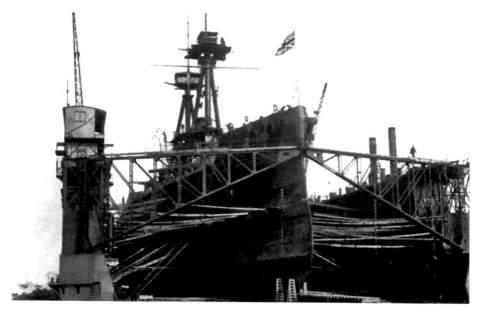

Floating Dock

We can be sure that this photograph was taken some time between the summer of 1912 and the spring of 1913. The purpose of installing the floating dock at Chatham was to enable the dockyard to repair and refit the largest battleships. However, the idea proved to be impractical and it was soon moved to Cromarty.

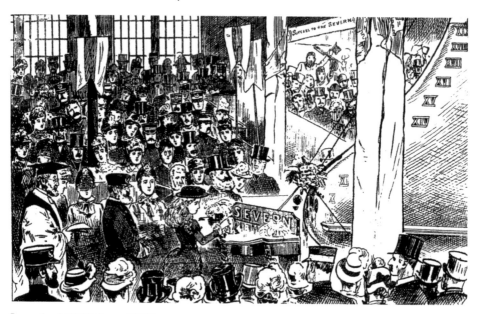

Launch of HMS *Severn* (1885)

Described as 'a fast twin-screw protected corvette', the *Severn* was launched by Marguerite Watson, the fourteen-year-old daughter of the dockyard's Admiral Superintendent. This vessel was intended to be an escort ship for merchant convoys in wartime. Only her conning tower was armoured and she was fitted with various calibre guns and torpedo tubes on each broadside. She was sold for scrap in 1905.

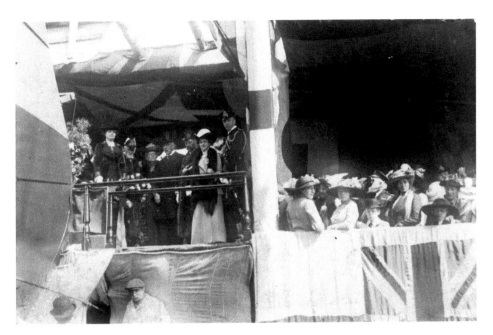

Launch of HMS *Lowestoft* (1913)

This light cruiser was launched at Chatham on St George's Day, 23 April 1913. Lady Beauchamp, the wife of the MP for Lowestoft christened the ship. The mayor and the mayoress of the Suffolk town and several councillors were in attendance. As Lowestoft hadn't had a coat of arms prior to this occasion, the town's council had hurriedly created one. It was used to decorate the front of the platform for Lady Beauchamp.

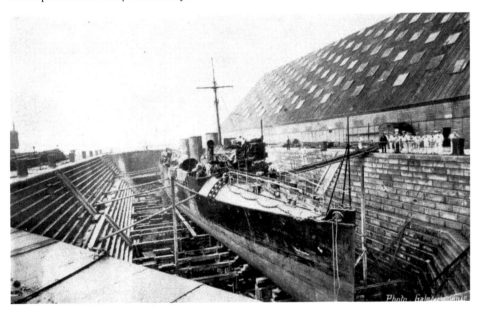

HMS *Greyhound* (c. 1905)

This ship, which was built on the Tyne and commissioned in 1902, spent her life in the Channel Fleet. During the First World War, the vessel participated in anti-submarine patrols, after which she was broken up. *Greyhound* is seen here in the No. 4 dock at Chatham Dockyard.

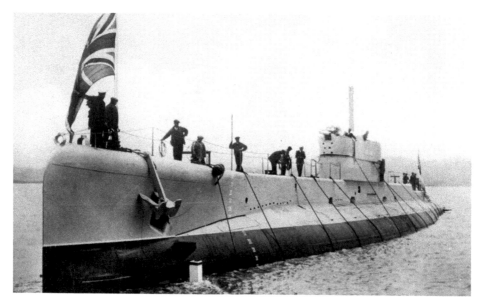

HMS *Oberon*

Starting in 1908, the yard's shipbuilding activities increasingly concentrated on submarines. HMS *Oberon* was launched in 1926, and although she served until 1944, she saw little action. After a collision with HMS *Thanet* at Devonport in 1935, the ship was placed in reserve. She was recommissioned at the beginning of the Second World War, but was used mainly for training purposes. The *Oberon* was scrapped in 1945. The first of a new class of submarines, also called HMS *Oberon*, was launched at Chatham in 1959.

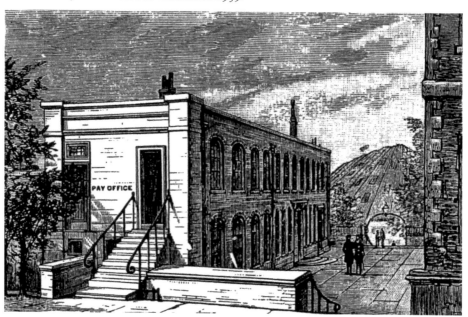

Dockyard Pay Office

Between 1817 and 1822, this was the workplace of John Dickens, the father of Charles Dickens. Some artistic licence has been used in the background of this picture, but the building itself is fairly accurately represented and may be seen today.

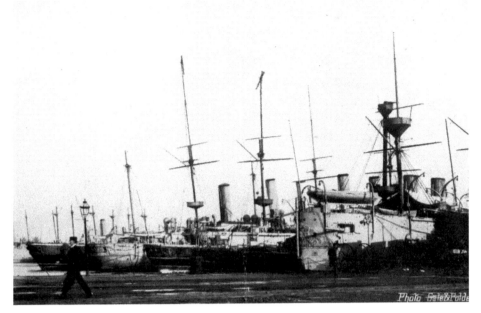

Chatham Dockyard – Ships in Reserve

These were some of the older ships held in reserve at Chatham before the First World War. It was from here that the old cruisers *Aboukir*, *Cressy* and *Hogue* sailed to their doom in the autumn of 1914.

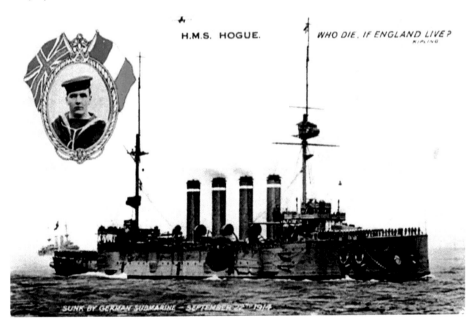

H.M.S. HOGUE.

WHO DIE, IF ENGLAND LIVE?
KIPLING

SUNK BY GERMAN SUBMARINE – SEPTEMBER 22ND 1914

HMS *Hogue*

In September 1914, a German U-boat attacked three elderly British cruisers that were on patrol in the North Sea. HMS *Aboukir* was the first to be torpedoed. The captains of HMS *Cressy* and HMS *Hogue* assumed she had hit a mine and stopped to pick up the survivors. They presented sitting targets to Captain Weddigen of U-9 and both were sunk.

Chatham Dockyard Scene (1924)
This unique photograph was taken from the deck of the light cruiser HMS *Calliope* in May 1924. HMS *Castor*, another light cruiser, is prominent among the vessels in the distance. Both ships were scrapped in the 1930s.

On the River Medway
This vessel is passing Chatham Dockyard in the early twentieth century. Note the pump house and the tall funnels of Victorian warships lying in the dockyard basins in the background.

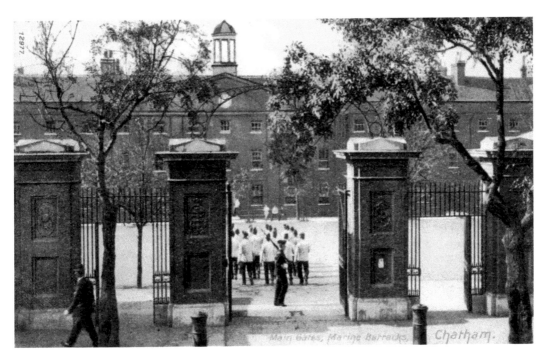

Main Gate, Royal Marine Barracks

While there had been a Royal Marine presence in Chatham since 1708, the barracks in Dock Road were only built in the late 1770s. In March 1950, it was announced that spending cuts were necessary and the Chatham Division would be dispersed to Portsmouth and Devonport. The Central Pay and Records Office remained at the nearby Melville Barracks until 1960, when it was transferred to Portsmouth.

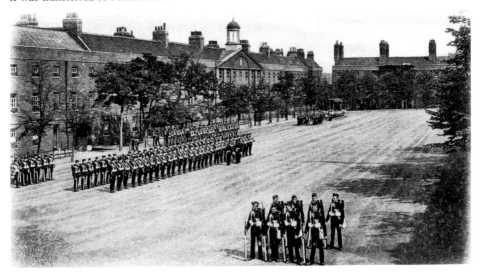

Parade Ground, Royal Marine Barracks

After closure in 1950, the Marine Barracks remained derelict and were eventually demolished. The site was an eyesore for many years and had several owners, including William Palfrey Ltd, the packaging manufacturers. Eventually, in the 1970s, the Lloyd's of London insurance group built offices on the site. These have now been taken over as the headquarters of Medway Council.

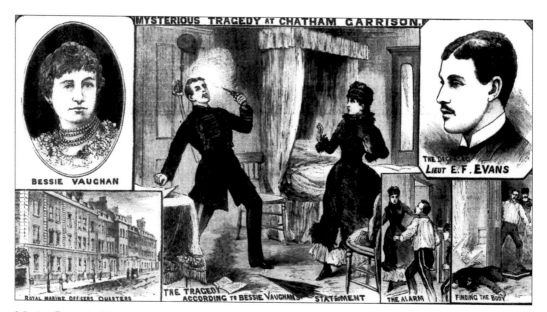

Marine Barracks Tragedy of 1886

These sensationalist drawings from the *Illustrated Police News* depict the suicide of Lieutenant Edgar Evans of the Royal Marines in April 1886. He shot himself in the presence of his lover Bessie Vaughan, whom he kept in a house in Ordnance Street. Before he pulled the trigger she had confessed to him that she had other lovers.

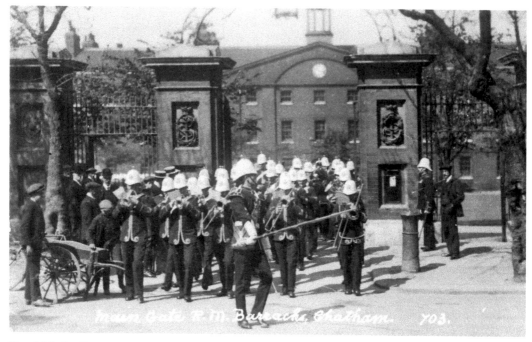

Royal Marine Band

The sight of the Royal Marine Band processing out of barracks, particularly when on church parade, was a common one. The sound and spectacle of these occasions were a traditional part of the landscape of Chatham.

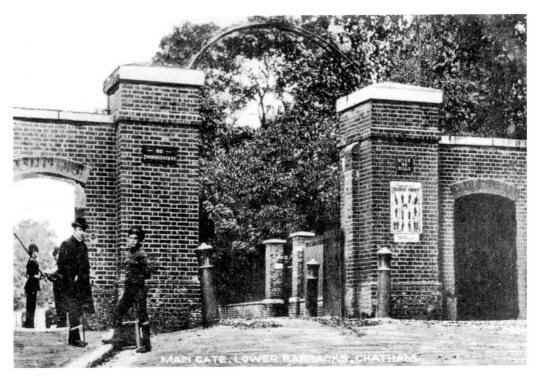

Main Gate, Lower Barracks

The regiments that acted as the Chatham garrison were housed in the Upper and Lower Barracks on Dock Road. This entrance to the Lower Barracks was situated on Amherst Hill. Notice the recruiting poster pasted on the pillar to the right.

Inside the Lower Barracks

This view of the Lower Barracks was taken from just inside the main gate. In the late 1920s, the War Office changed the names of the Upper and Lower Barracks to Kitchener Barracks. These buildings were replaced in the 1930s. They may still be seen facing Dock Road.

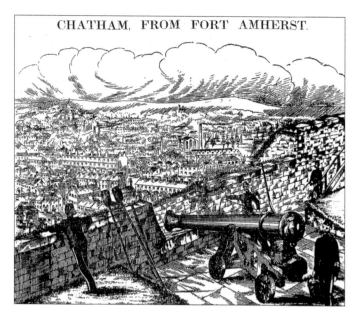

CHATHAM, FROM FORT AMHERST.

Chatham from Fort Amherst

Fort Amherst started life in the mid-eighteenth century. It formed part of the complex set of fortifications built on the high ground overlooking Chatham and its dockyard. The most notable parts of the fort were built during the Napoleonic Wars of the early nineteenth century. This picture from 1887, although crudely drawn, provides a good impression of a sentry's eye view of Chatham from the fort.

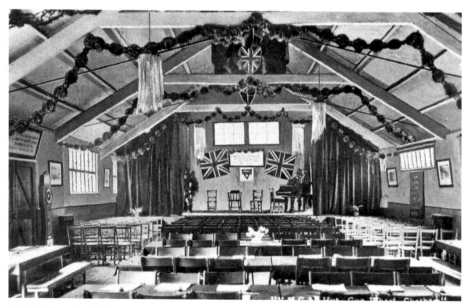

YMCA Hut, Dock Road

During the First World War, the Young Men's Christian Association (YMCA) built temporary huts near military facilities. These were intended for respectable recreation, refreshment and entertainment for troops. This one was in Dock Road opposite Gun Wharf. It did not close until the 1960s, which meant it lasted longer than most.

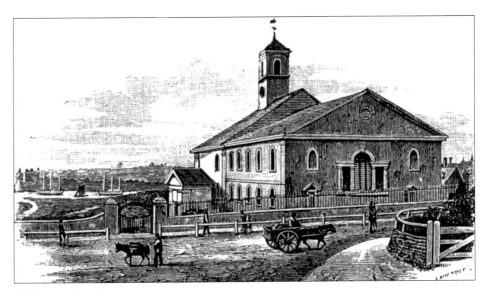

St Mary's Church

Saxon, Norman and medieval parish churches existed on this spot. As Chatham developed into a dockyard town, the latter proved to be inadequate. Extensions and botched repairs followed until the eighteenth century, when the idea of a completely new church was considered. However, the congregation rejected this, probably on grounds of cost. A major renovation was therefore undertaken in 1780. The medieval nave and chancel were demolished and replaced in the fashionable neoclassical style. The exterior was now of brick, plain and nearly square. The building was attended by the young Charles Dickens and his family.

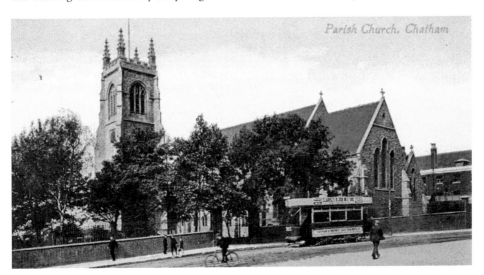

St Mary's Church, Victorian Building

The church building that exists today is the result of further major reconstruction. This began in the 1880s and was not completed until 1903. Most of the church's classical features were removed in favour of a Gothic Revival design. The Victoria Tower, detached from the church proper, was added to house eight bells. Each had an inscription commemorating its donor. The church was declared redundant in the 1970s and a long debate regarding its future ensued. In the mid-1980s it became the Medway Heritage Centre, but now lies empty, its long-term future still to be decided.

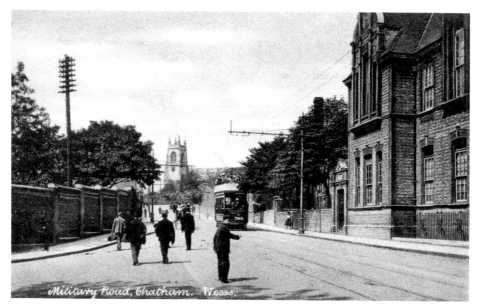

Church Hill

Despite this postcard's caption, this view shows Church Hill looking towards St Mary's church. The Royal Marine Schools, completed in 1879, lie to the right, while the walls (since demolished) surrounding Gun Wharf lie to the left. The code on the front of the tram descending the hill reveals that it is on the Gillingham to Town Hall route.

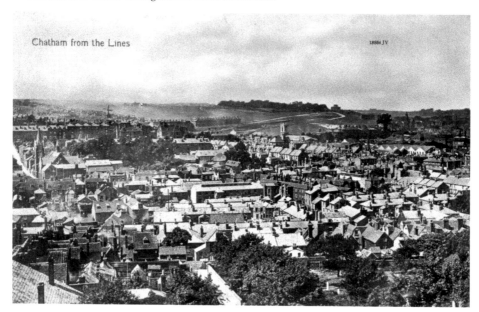

View Over Chatham Looking Towards Fort Pitt

The War Department owned large tracts of land surrounding Chatham, which could not be built upon. Consequently, central Chatham was developed on the remaining available plots and was very densely populated. On the left is the Ebenezer Congregational church. The tower in the middle of this view belongs to St John's church. In the centre of the picture, near the horizon, stands Ordnance Terrace at the bottom of the hill leading to Fort Pitt.

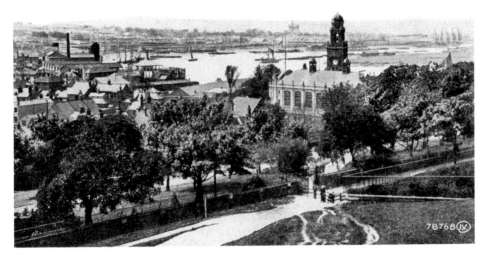

View Over Chatham Looking Towards Rochester

The footpath from the Lines leads down, via the former burial ground, to the town hall. Thames barges may be seen on the river and, in the distance, are Rochester Castle and the spire of the city's cathedral.

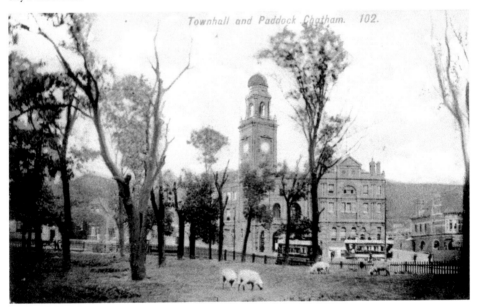

The Shrubbery

This piece of ground, lying between Military Road and Globe Lane, originally belonged to the War Department and was used to store timber. By the 1860s it had become neglected and the authorities were concerned that it was being used for immoral purposes. The Board of Health took it over in the late 1870s and as 'The Shrubbery' it had a variety of uses, including a grazing area for sheep.

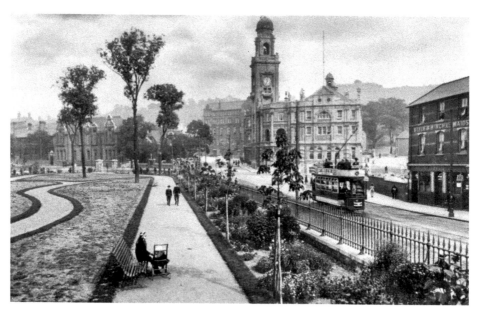

The Paddock

By the early twentieth century, The Shrubbery, renamed The Paddock, had been laid out as a pleasant promenade, often described as a 'lung' for Edwardian Chatham. The Paddock was later used for a market and a car park. When the Military Road shops were demolished to make way for the Pentagon Shopping Centre in the early 1970s, their tenants were relocated to temporary buildings in The Paddock. Later it reverted to its recreational role.

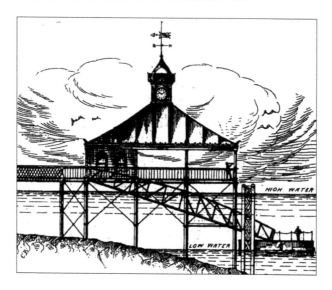

Sun Pier

This landmark was built in 1885, replacing an earlier structure. It was designed by Sir Joseph Bazalgette and financed by a grant of £3,500 by the Rochester Bridge Wardens. The pier head contained waiting rooms and offices. In the centre of its roof was a cast-iron turret with a clock and weather vane. A floating pontoon, linked to the pier by a hinged gangway, rose and fell with the tide, enabling steamer passengers to disembark at any time. A fire in 1972 destroyed the building on the pier head, leaving Sun Pier a shadow of its former self.

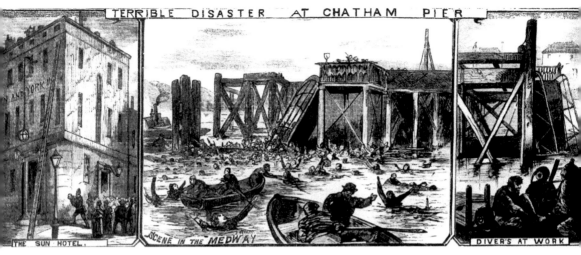

Collapse of Sun Pier (1885)

Despite the sensationalist nature of the caption, there were no fatalities. Only minor injuries were incurred when a temporary gangway, packed with passengers waiting to board river steamers, collapsed in July 1885. Hundreds were pitched into the River Medway, but were rescued almost immediately. The policeman on the left is taking a child into the Sun Hotel, where the injured were looked after.

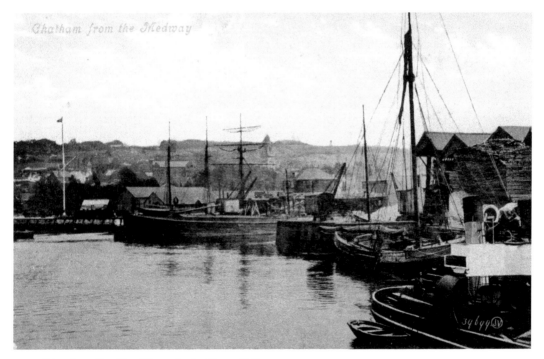

Riverfront Looking Towards the Town Hall

A good impression of the varied commercial shipping to be found on the River Medway in the Edwardian period can be seen here: a tug, a Thames barge and a barque are all present. Bessent's timber yard may be clearly seen; Holborn Wharf is beyond it. The wharf contained storage facilities for the Anglo-Iranian Oil Company and deep pits for storing ice imported from Norway. In 1914, an ice-making factory replaced the latter trade.

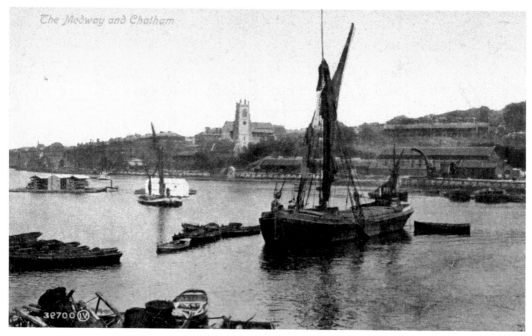

Gun Wharf from Sun Pier

The Sun Pier enabled photographers to record a wide range of riverside activities. A Thames barge dominates this Edwardian photograph, with Gun Wharf and St Mary's church in the background. On the left lie rafts belonging to the local rowing club and HM Customs.

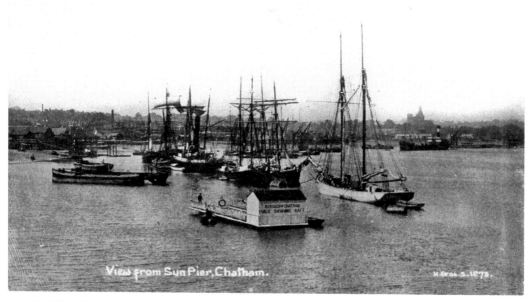

Looking West Towards Rochester

This view from Sun Pier emphasises the importance of Chatham as a commercial port as well as a naval base. Sailing vessels dominate the foreground and a steamer is visible at the back. Note the Borough of Chatham public swimming raft in the centre.

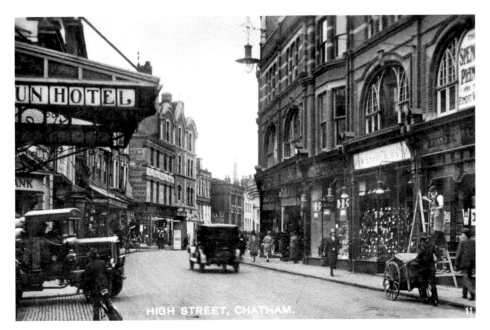

Medway Street/High Street Junction

The view of this busy intersection looks eastwards from the Sun Hotel. The lorry is emerging from Medway Street. Part of the block built by George Leavey may be seen on the right, including Murdoch's piano manufactory, HS Footwear Company and Bates department store. Leavey's own shop is around the corner next to Manor Road.

William Cuffay

Born in 1788 to an English mother and a father from the Caribbean, Cuffay is one of Chatham's most notable progenies. He served as an apprentice at Acworth's tailor shop in the High Street. After moving to London he became nationally famous for his radical politics. Following a trial for sedition he was transported to Tasmania in 1849. Cuffay died there in 1870.

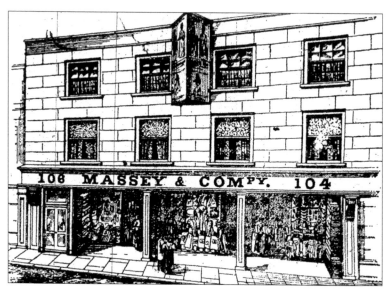

Massey's Drapery

Joseph Massey's shop lay on the High Street between Hamond Hill and Railway Street. Massey died in 1897. Two years later the shop disappeared when this section of the High Street was redeveloped to accommodate the Theatre Royal and adjoining properties.

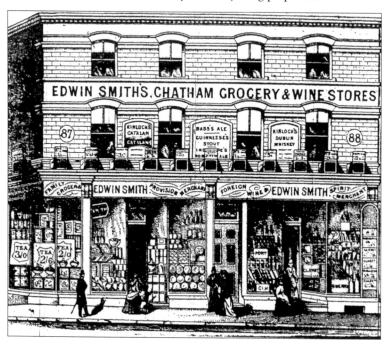

Edwin Smith's Grocer's Shop

This High Street grocery was sited in what was once a thriving part of Chatham. It was situated on the corner of the High Street and Higgins Lane, adjoining Barnard's Palace of Varieties and directly opposite the Theatre Royal. By the beginning of the First World War a tailor had taken over part of the premises, and by 1930 this long-established grocery had become the Ivy Leaf Club.

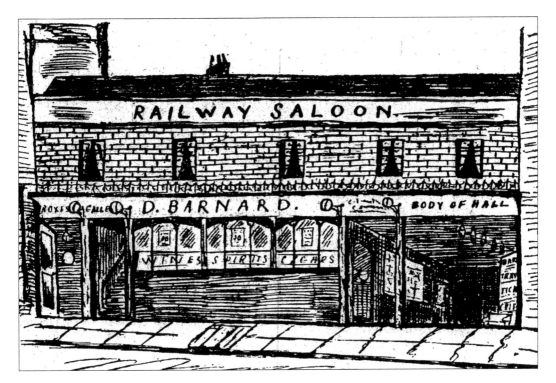

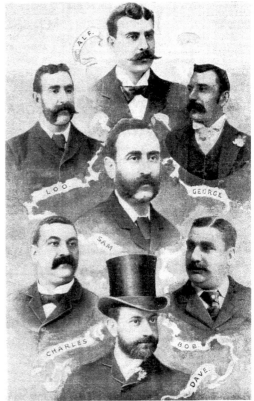

Above: Barnard's Palace of Varieties
Daniel Barnard, soon to be a leading member of Chatham's Jewish community, purchased the Railway Saloon pub in the High Street, west of Rome Lane, in 1849. Following a national trend for pub-based entertainment, Barnard demolished the pub's skittle alley and constructed a purpose-built entertainment room or 'music hall'. This adjoined the Railway Saloon but had its own entrance. The venue flourished and outlived Daniel Barnard, who died in 1879. When this largely wooden building burnt down in 1885, Barnard's son Lou set to work replacing it.

Right: The Barnard Brothers
Daniel Barnard's sons were also involved in the entertainment business. Lou and Charles owned theatres locally. Charles also owned venues in the West Midlands and the Elephant and Castle Theatre in London. Samuel was the proprietor of the Woolwich Empire and Alfred owned a theatre in Liverpool. David became a publican in the Medway Towns.

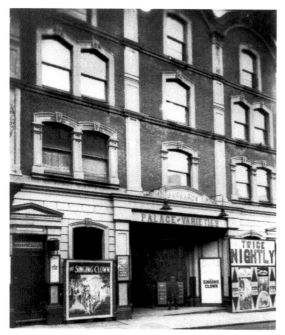

Barnard's New Palace of Varieties
Following the destruction of the original premises, Lou Barnard, in partnership with the freeholder Watts Charity, constructed this purpose-built music hall. It was a plain, flat-fronted, red-brick structure, designed by J. W. Nash of Rochester. Although uninspiring in itself, the four-storey building dominated this part of the High Street. It could accommodate more than 1,000 patrons. Barnard's survived competition from rivals, and was still flourishing when it burnt down in 1934. It was not rebuilt.

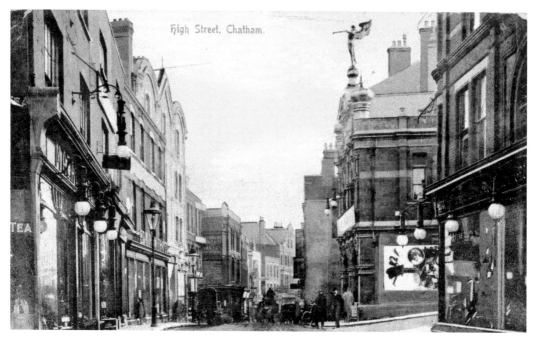

Theatre Royal
In 1899, Lou Barnard, with his brother Charles, opened the Theatre Royal in the High Street, on the corner of the newly built Manor Road. This was part of a major redevelopment of the western end of the High Street. This building contrasted with the austere Palace of Varieties, which lay opposite. George Bond, the Theatre Royal's architect, gave it an ornate exterior, surmounted by a gilded figure of Victory on the roof. The theatre was just as elaborately decorated inside and could accommodate 3,000 patrons.

Theatre Royal Continued

A serious fire in May 1900 necessitated the partial rebuilding of the Theatre Royal. It reopened on Christmas Eve, 1900. The Barnards' original intention was to present 'straight plays', but they were soon forced to add musical comedies and revues to the theatre's repertoire. It survived until 1955. After retail use, unsuccessful attempts were made to raise funds for its renovation. At the time of writing, the building is being converted for housing, its original façade retained and renovated. Beyond the theatre in this picture is Leavey's department store, which opened in new buildings in 1901.

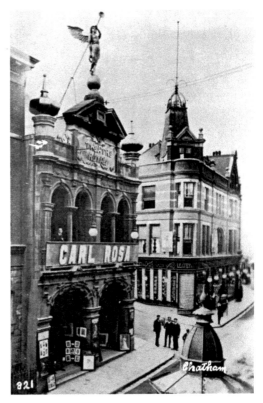

Theatre Royal Programme Cover

While the representation of the Theatre Royal itself is accurate, one wonders how often formally dressed audiences like the one depicted here attended the theatre's performances. This cover is of a striking design, but perhaps more appropriate to the West End of London rather than that of Chatham.

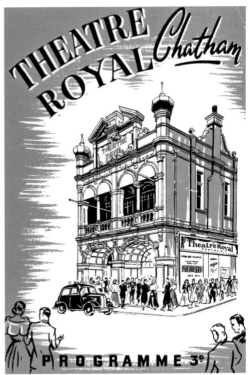

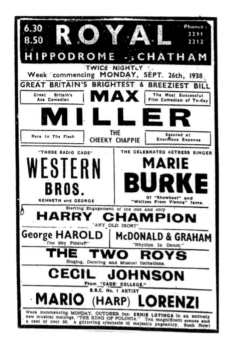

Theatre Royal Advertisement (1938)
The theatre was badly damaged by fire in late 1937. It reopened the following year with a new name – The Royal Hippodrome. In this weekly bill, Harry Champion, an Edwardian comedian at the end of his career, has lower billing than that of the up-and-coming Max Miller. Notice also how the radio careers of the Western Brothers and Mario Lorenzi are emphasised in their publicity.

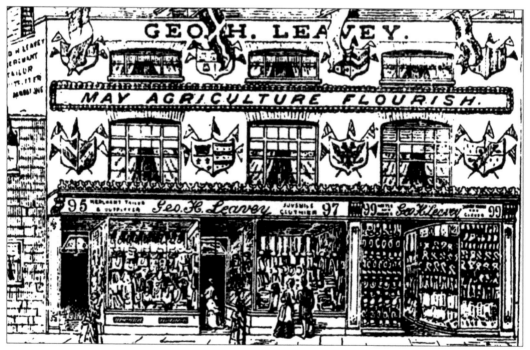

G. H. Leavey's Outfitters, Nos 95–99 High Street
George Leavey opened his gentlemen's outfitters business in the High Street in the 1880s. The shop was situated just east of the Medway Street corner. Here it is decorated to celebrate the local agricultural show of 1890. By 1899, the premises were too cramped and Leavey purchased the site of the old Chatham brewery, which lay almost opposite. He opened a new shop on this site in 1901. The stationers WHSmith opened on Leavey's original site in 1924.

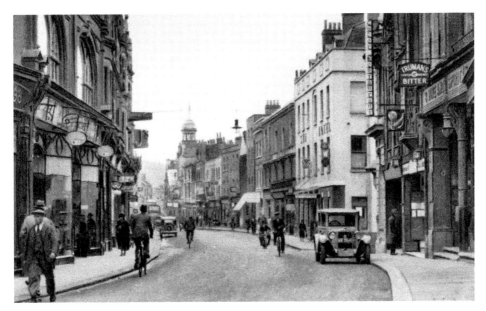

Sun Hotel

This establishment stood on the site of the old Sun tavern, destroyed by fire in 1820. The Sun Hotel provided refreshments and accommodation. It also supplied changes of horses from 1821, until the railways killed the stagecoaches in the 1860s. It continued to be a meeting place for local clubs and societies and catered for artistes appearing at Barnard's and the Theatre Royal. The Sun Hotel closed in 1965 when it was owned by Trust Houses Limited, and was later demolished.

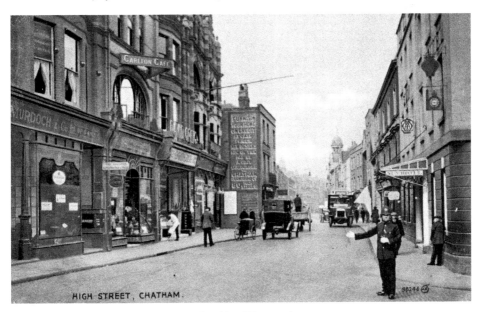

Medway Street/High Street Junction Looking Westwards

The policeman is directing traffic outside the Sun Hotel. Across the road is part of the imposing block of shops built by George Leavey in 1901. Tenants included Murdoch's piano manufactory, David Greig's grocer and the Carlton Café. Beyond these shops is the former Cinema de Luxe, by then renamed the Silver, protruding from the building line.

George Pagett

The dapper figure in this photograph is George Pagett, who ran a gentlemen's hairdressers at No. 83 High Street from around 1912 to 1934. This establishment, which was situated next door to the Sun Hotel, later became a long-standing wool shop. George Pagett died in 1950.

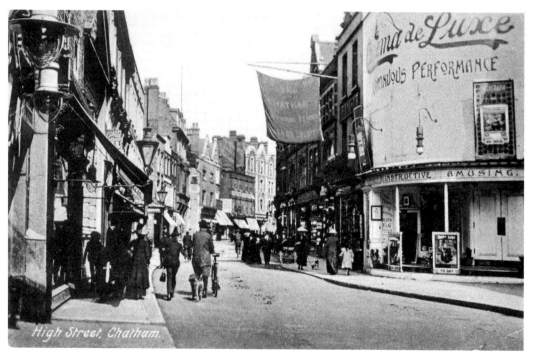

Cinema de Luxe

This was Chatham's first cinema, which opened in January 1910 in a converted shop. It was small by later standards, consisting of a single storey and capable of accommodating a few hundred patrons. Seat prices were a uniform 3d (equivalent to just over 1p in today's money). The Cinema de Luxe soon paid the price for being a pioneer, as later cinemas were larger and much more luxurious. A change of name to the Silver and a refurbishment in 1920 did nothing to improve the cinema's prospects. It closed at the end of the following year.

Empire Theatre

In 1912, the former Gaiety Music Hall at the western end of Chatham High Street reopened as the Empire Theatre of Varieties. It was under the joint ownership of the Gaiety's proprietor Henry Davis and Oswald Stoll, the theatrical magnate. The Empire was designed by Frank Matcham and was twice the size of the old Gaiety. Although a cinema in the 1930s, the Empire reverted to variety during the Second World War. Threatened by television, it staggered on through the 1950s. It closed in 1961 and was demolished in 1962.

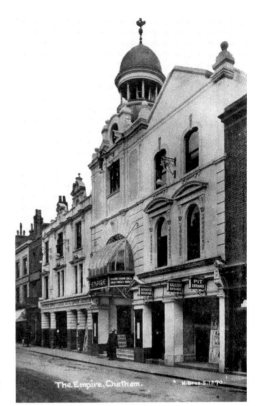

The Empire, Chatham.

Empire Theatre Programme Cover

This Art Deco cover of an Empire Theatre programme dates from 1930. From then until 1939 live entertainment ceased and it became one of the Medway Towns' leading cinemas. Next door was the Picture House, also belonging to the Stoll organisation, which showed films of a second run or second-rate nature. Live entertainment returned to the Empire during the Second World War, when it once again became a fully fledged variety theatre.

Ladies' Latest Hairdressing
The latest style adapted to every individual need~
Permanent & Marcel Waving~
Shingling a speciality ~
A.J. IRELAND
352 High St. Rochester
Chatham Intra
'Phone 2772

GENTLEMEN :—You will secure High-Class Attention. Where all Antiseptic & Disinfection precautions are adopted. With Courtesy we Solicit a Trial.

SHEPHERD NEAME LTD
FAVERSHAM ALES
MALT & HOPS ONLY
ON SALE AT THE BARS OF THIS THEATRE

The Latest in Eyewear
The "P.C." Frame
The only frame on the market with a right bridge and therefore CANNOT get out o alignment, WILL NOT MARK THE NOSE.
Sight Tested Free. REPAIRS WHILE YOU WAIT.
C. HOLLINGSWORTH,
Sight Testing Optician,
392a, HIGH STREET, ROCHESTER
Special Discount on Hospital Prescriptions.

GO TO
LLOYD-LANGSTON
FOR
GRAMOPHONES,
RECORDS,
FANCY CHINA,
LEATHER GOODS
of all kinds,
and the
FINEST FICTION
LENDING LIBRARY
in the District.

285 & 238,
HIGH STREET,
CHATHAM.

PROGRAMME

1 OVERTURE

2 GIRL OF THE PORT

Josie.......................Sally O'Neil
Jameson...........Reginald Sharland
McEwenMitchell Lewis
McDougal......Donald MacKenzie
Kalita..........Duke Kahanomoku
Bruce.................Gerald Barry
Burke......Arthur Clayton
Blair................Barry O'Daniels
Cole.....................John Dillion
Toady..................William Burt
Wade...............Hugh Crumplin

PICKFORDS
REMOVAL & STORAGE SERVICE.
Any Distance. - Any Quantity
371, High St., ROCHESTER.
King Street, GILLINGHAM.

ASK FOR
MACKESON'S
MILK STOUT
On Sale at Theatre Bars.

3 NOT DAMAGED

Gwen Stewart...............Lois Moran
Charlie Jones...........Robert Ames
Kirk Randolph.........Walter Byron
Maude Graham.........Inez Courtney
Elmer... George "Red" Corcoran
Peebles....................Ernest Wood
JennieRhoda Cross

4 PIANO TUNERS

5 AFTER THE BALL

FREMLIN'S
ALES
&
STOUTS
ARE ON SALE IN THIS
THEATRE
ON DRAUGHT
OR
IN BOTTLE.

Minerals of Quality
AS SUPPLIED TO THE BARS
OF THIS THEATRE
BY
DOVE, PHILLIPS & PETT, Ltd.,
277, HIGH STREET, ROCHESTER.
ESTABLISHED 1848 'PHONE 3375.

For Billposting, Advertising-Cars,
Sandwichmen, Handbilling, etc.,
GO TO
PARTINGTON'S (Kent)
BILLPOSTING, LTD.,
The Firm with branches in all towns in the South-east of England.
—:o:—
Head Office
Publicity House, High St.,
Rochester

THE WEST END FLORISTS.
LAWRENCE & SON,
LIMITED,
2, High St., CHATHAM.
— :: —
Try our Selected Strains of
VEGETABLE & FLOWER
— SEEDS —
Visit our Nurseries at Allamy Road, Luton Road.

COOPER'S for RADIO
Official Distributors for Model "55" Portable
Marconiphone
BROADCAST RECEIVING APPARATUS
A. COOPER & SONS
340, HIGH STREET,
'Phone 2413. CHATHAM.
£18 18 0.
or 7/6 WEEKLY

Above: Empire Programme, Week Beginning 30 November 1930
While the titles of these films and their stars are long forgotten, the names of several of the businesses advertised here were longer-lived. Lawrence & Son, Lloyd-Langston and Coopers survived in Chatham for many decades, although sadly all have now disappeared.

Left: At the Boundary with Rochester
The man in the foreground is standing on the Rochester/Chatham boundary outside St Bartholomew's chapel. He is looking east towards Chatham. Beyond the man is Lawrence's florist shop before rebuilding. Opposite, out of sight, would have been the Sir John Hawkins Almshouses. Note also the pavement artist nearby.

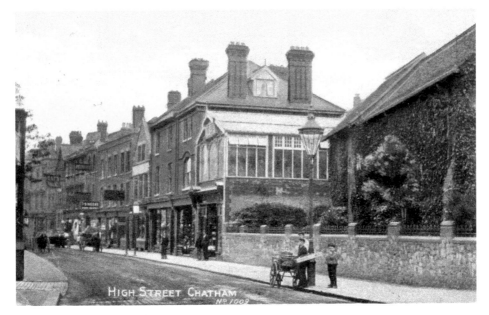

Henry Lawrence's Florist Shop

In 1867, Henry Lawrence arrived in Chatham from Cambridge and set up a floristry business. His shop was situated next to St Bartholomew's chapel, and his nursery was at the top of Albany Road in Luton. The business was so successful that Lawrence invested in new premises on the same site in 1903. This building became quite a landmark at the extreme western end of Chatham High Street, largely due to its attractively designed greenhouse surmounting the shop below. The building is now used as a restaurant.

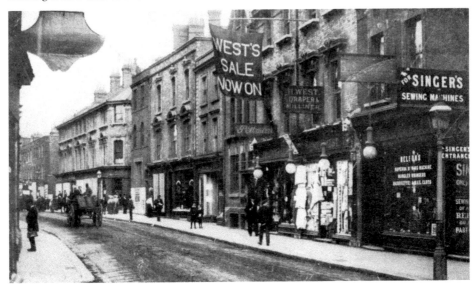

West End of High Street, Chatham

A little east of Lawrence's was the Singer sewing machine company premises. Next to it was Robert Nelson's domestic machinery shop, which also sold sewing machines, as well as mangles, wringers and so on. Beyond Nelson's was Henry West's draper's shop and Richard Pittman's outfitters. The offices of the *Chatham News* lay a few buildings down on the corner of Gundulph Road.

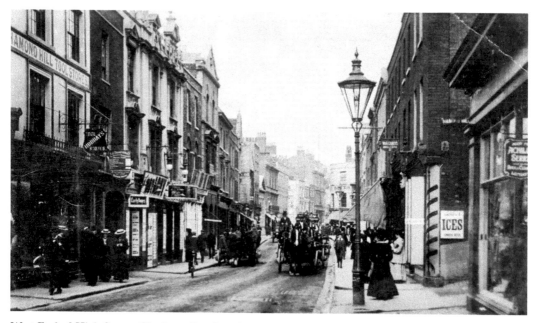

West End of High Street, Chatham Continued

Still looking eastwards, we are now at the corner of Hamond Hill. Opposite are the Hamond Hill Tool Stores and the Gaiety Music Hall before it was transformed into the Empire. On the centre right, jutting out from the building line, is Bates department store, before it became the Cinema de Luxe.

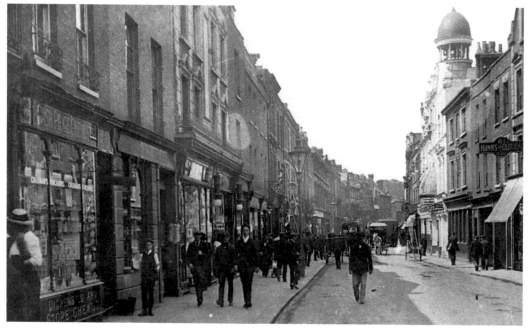

Some West End Shops

This time we are looking west towards Rochester, with the Gaiety in the distance on the right. On the left, at No. 68, is Goldstone & Cook, dispensing chemists. Next door is an off-licence belonging to Budden & Biggs, followed by the draper, Read Parish & Son.

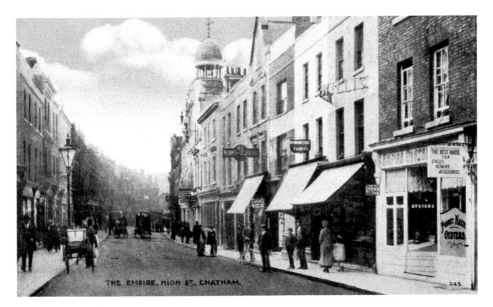

More West End Shops

We are looking towards the Empire Theatre, enjoying the hustle and bustle of the area. Just before the First World War this part of Chatham High Street could boast photographer A. E. Willis, Brinsted florist's and Ernest Nunn's hosiery shop. At that time, hungry shoppers could savour flavoursome local oysters at the Empire Oyster Bar – food that is today considered a privilege for the wealthy.

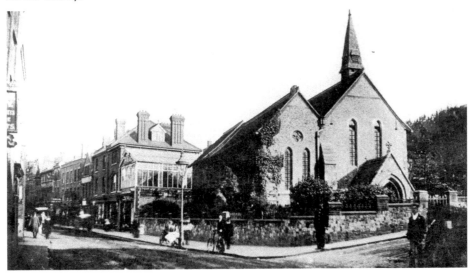

St Bartholomew's Chapel

This building was constructed in the eleventh century. It served the nearby St Bartholomew's Hospital for lepers. The medieval hospital buildings are long gone and the chapel itself has undergone several renovations. The most important of these were carried out by Sir Gilbert Scott in the 1870s. Some long-lost Norman features were restored while other original elements were replaced. When built, the hospital and chapel stood almost alone, well outside the walls of Norman Rochester and to the west of the village of Chatham. Both communities expanded and the chapel now marks the border between them.

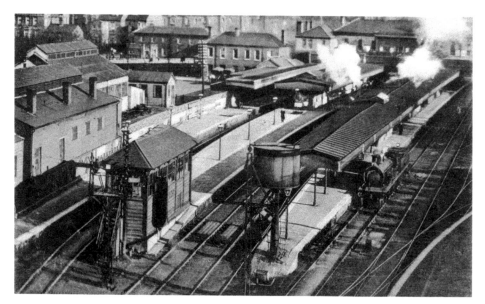

Arriving at Chatham

When Charles Dickens was a boy living at Ordnance Terrace, the area in front of the house consisted of fields leading down to the Rome Lane arch. In the 1850s, this area was dug out and Chatham station was constructed in the deep cutting. By the 1880s, the original structure had become inadequate and was replaced by five 600-foot-long platforms for civilian passengers. Additionally, a military platform was provided with its own line for the use of large bodies of troops and their equipment.

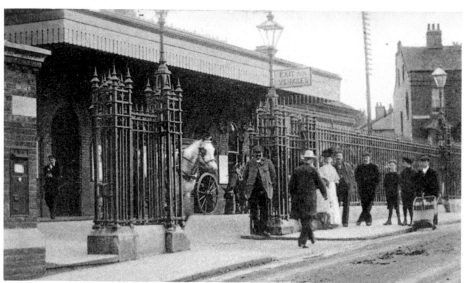

Chatham Railway Station

This station was built in 1884 to replace the original wooden structure. It continues to serve the travelling public today. For passengers' convenience, brick-built waiting and refreshment rooms and lavatories were constructed on the new platforms. Above, the road bridge over the railway was widened to accommodate the booking hall and parcels and telegraph offices. A courtyard, carriage drive, covered promenade and cabstand were also constructed on the bridge.

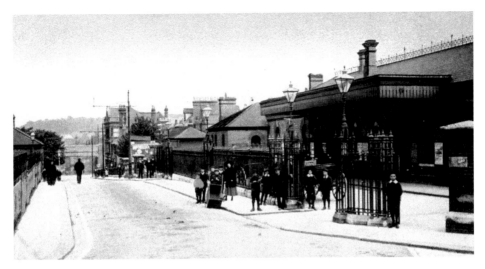

Gateway to the Town

On leaving the station, visitors turned right in order to walk down to the town. The New Road viaduct, underneath which they would pass, may be seen in the distance. If visitors wished, they could have stopped for refreshments at the Alexandra Hotel first. Alternatively, turning left would bring them to Ordnance Terrace, where Charles Dickens had once lived.

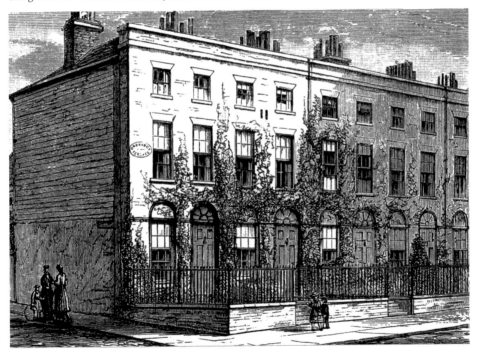

No. 2 Ordnance Terrace

This house, now No. 11, was the home of the Dickens family from April 1817 until some time in 1820. The land on which it was built had been part of Rome Lane Farm. This had belonged to Watts Charity, which had recently sold it for development. In the days before the railways, fields sloped from the terrace down to the arch at the top of Rome Lane, later renamed Railway Street. Dickens later referred to this area as 'the most airy and pleasant part of the parish'.

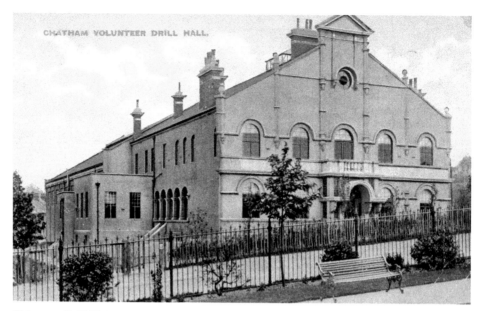

Volunteer Drill Hall

Situated in Boundary Road at its junction with Fort Pitt Hill, this building was opened by Lord Roberts in 1905. It housed the 4th (Territorial) Battalion of the Royal West Kent Regiment. During the First World War, the building was used as a temporary military hospital. It was demolished in the 1930s and replaced by a new building. By 1970, the site was derelict and was sold to the builders Ballard for new housing.

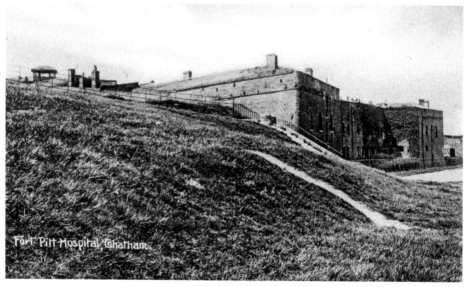

Fort Pitt

This fort, along with forts Clarence and Delce, was built to improve the protection of Chatham Dockyard from Napoleonic France. By the time it was completed in 1819, the threat had gone. It was soon converted, with appropriate extensions, into a military hospital. The War Department sold off Fort Pitt in the late 1920s, and the Chatham Day Technical School for Girls moved from Elm House on New Road to the old fort. Much expanded, it is now Fort Pitt Grammar School.

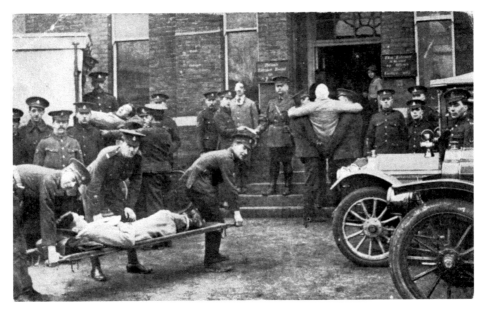

Fort Pitt in the First World War

The hospital could accommodate 550 patients and had a staff of more than 400. In this picture, a new casualty is being carried to the receiving room for assessment before being transferred to the surgical, medical or other departments. The hospital also continued to receive outpatients from the local garrison.

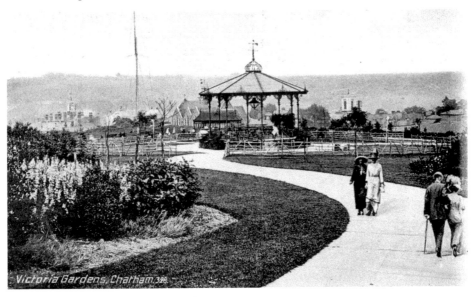

Victoria Gardens, Chatham.

Victoria Gardens – A Tribute to the Queen

With breathtaking views of the River Medway, the dockyard, Rochester Castle and Cathedral, this site was an ideal spot for the newly created Chatham Borough Council to design a park for its residents. The land, adjacent to Fort Pitt, was rented from the War Department. It was laid out as public gardens and opened in commemoration of Queen Victoria's Diamond Jubilee in September 1897. In 1908, the council purchased the freehold for £1,250, the War Department's stipulation being that it would remain an open recreational space.

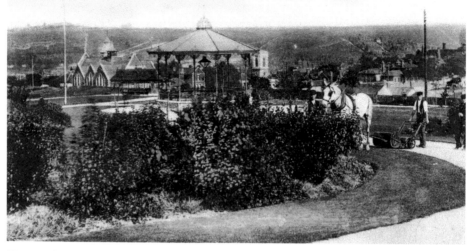

Victoria Gardens – Differences of Opinion

Two churches flank the bandstand in this Edwardian picture – St John's on the right and St Andrew's Presbyterian on the left. Objections to the so-called 'continental Sunday' led to the banning of concerts at the gardens on the Sabbath. The newly opened Royal Naval Hospital may be seen on the Great Lines to the left. Note the workman with the horse-drawn mower.

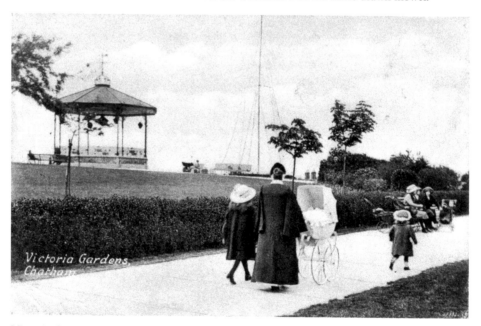

Victoria Gardens – Family Outings

Lying above the town as they did, the Victoria Gardens provided an ideal place to take the children for a walk. The writer of this card, which was posted in October 1914, informed his girlfriend that 'The King and Queen are coming down here to inspect us this afternoon, so we shall have to look up. Been preparing for it this morning with rifles and bayonets...'.

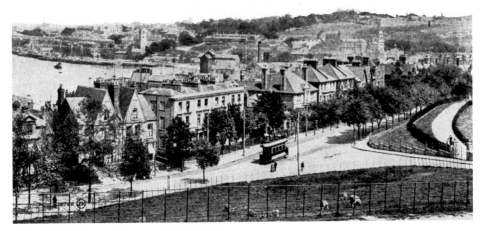

A View from Fort Pitt Fields

The sheep grazing at the bottom of Fort Pitt Fields provide rural charm to this otherwise urban picture. The dockyard, the Infantry Barracks, Fort Amherst and Chatham Town Hall lie in the background to this view of New Road.

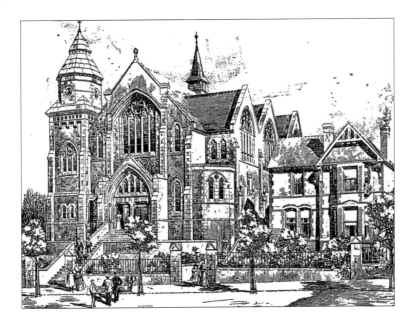

St Andrew's Presbyterian Church, New Road

The original Presbyterian church stood nearby in New Cut. A small, ironclad structure, it was inadequate and dilapidated by the 1890s. This new and larger building replaced it in 1904. Both churches were subsidised by the government and, in return, the church had to reserve pews for servicemen. This grand building, like so many in the Medway Towns, was designed by George Bond. It still stands but is now named King's church and has been used by an Evangelical denomination since 1988.

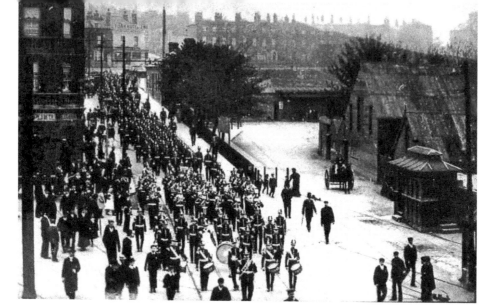

Railway Street, Upper End

Columns of troops marching to and from the railway station were a common sight in the Victorian and Edwardian periods. Here we see the 4th Battalion of the Royal West Kent Regiment marching past the Alexandra Hotel, which is on the left. On the right is a London cabmen's shelter, many of which were dotted around the Medway Towns.

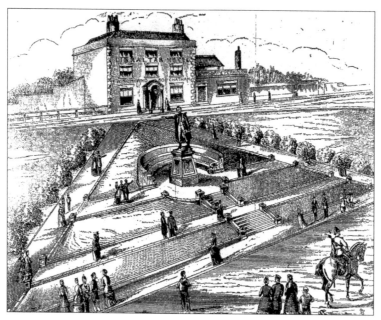

Waghorn Memorial – Plans

Thomas Waghorn was born in Chatham in 1800. His claim to fame was to devise a route from Britain to India that avoided the lengthy voyage around the Cape of Good Hope. The 'Overland Route' was via the Mediterranean, overland from Cairo to Suez and then by sea to Bombay. Waghorn died in London in 1850. Fundraising for a statue commemorating his achievement began in 1883. This is an artist's impression of the planned memorial, which was to be placed on 'Gibraltar Green'.

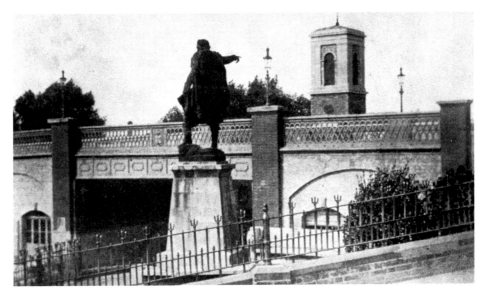

Waghorn Memorial Unveiled

The local memorial committee, supported by the developer of the Suez Canal, Ferdinand de Lesseps, and the P&O company, among other subscribers, commissioned the sculptor Henry Armstead. The bronze statue was intended to be an impressive introduction to Chatham for rail travellers and was unveiled in 1888. It is 8 feet 4 inches high and weighs a ton and a half. The Portland stone pedestal with a granite step is 9 feet high. A change from the statue's originally intended location means that Waghorn is pointing north rather than east.

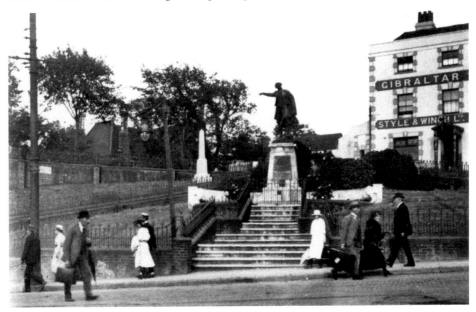

HMS *Barfleur* Memorial

A white stone obelisk stands behind the Waghorn memorial in this 1920s photograph. The memorial was paid for by the men of HMS *Barfleur* – a vessel assigned to China Station between 1898 and 1902. It commemorates twenty-four of their shipmates who died during the so-called Boxer Rebellion period.

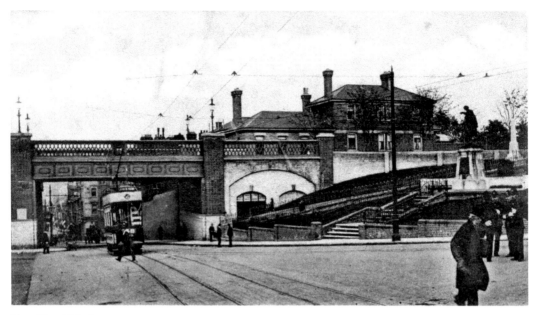

New Road Viaduct

By the 1890s, the brick bridge, or viaduct, that took New Road over Rome Lane (Railway Street) had become inadequate. A new viaduct, financed mainly by Chatham Council, was completed in 1902. Its piers are of Kentish ragstone. The rest is of red brick, including many that were recycled from the original viaduct. The road above is twice the width of the original. Underneath, a single, rectangular arch enabled trams to pass each other easily. A fire station, public lavatories and a barber's were built underneath.

Fireman Henry Swan

At a time when there was no borough or county fire service in Chatham, it made sense to High Street businessmen to create their own brigade, especially as many of their shops were of wooden construction. One such was Henry Swan, who owned a drapery at No. 331 High Street. Swan died in a nursing home at the age of forty-nine in March 1911. His death was from natural causes, but due to his long service it was decided to accord him a full fire brigade funeral.

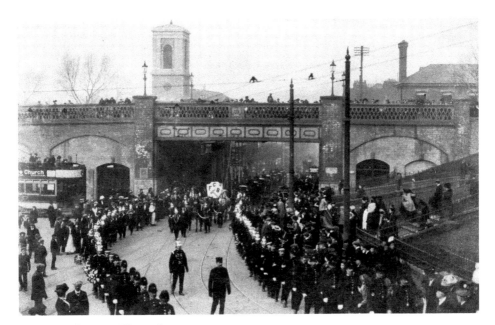

Funeral of Fireman Henry Swan

The cortège under the New Road viaduct made its way from St John's church to Chatham cemetery. Fireman Swan's helmet was placed on the coffin, which was covered with the Union Flag. A floral shield of white stocks 4 feet in height contained the letters CFB in red carnations and a fireman's axe in violets. The procession was led by Superintendent Rhodes of the Chatham Police and included representatives from brigades in the local area.

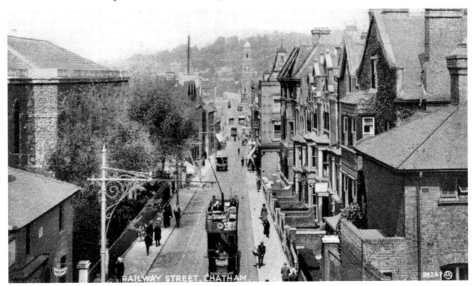

Railway Street

Before the railway came to Chatham in the 1850s, this was known as Rome Lane. On the left was a row of walnut trees fringing a meadow and farm belonging to Jacob Bryant. On the right, a red-brick wall enclosed a deer park and paddock belonging to Rome House. The Chatham Local Board of Health renamed it Railway Street in the 1860s, and it was transformed into a busy Victorian thoroughfare, with wagons, carts and cabs travelling to and from the new station.

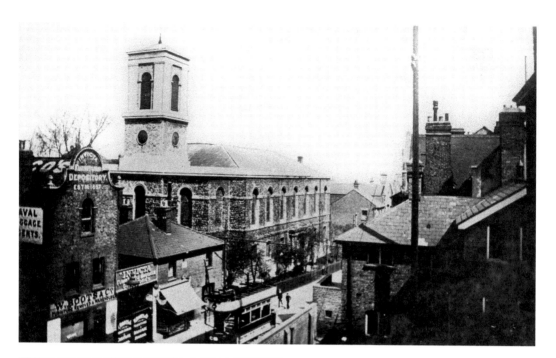

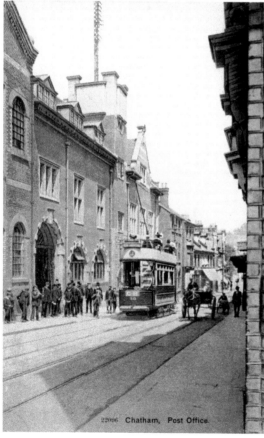

Above: St John's Church

Chatham's population rose as the dockyard expanded, and St Mary's church became inadequate for the town's needs. A shortage of church accommodation was also a national problem that was addressed by Parliament in the Church Building Act of 1818. The new law set aside £1 million to fund the construction of new churches. These were sometimes called 'Waterloo Churches' as they also acted as memorials to the victory over Napoleon. St John's, which opened in Rome Lane in 1821, was an example.

Left: Chatham Post Office, 1902

By 1896, Rainham had become part of the Chatham Postal District. At the same time, telephone trunk lines were nationalised, so the General Post Office required an exchange. Education reforms had led to an increase in literacy, resulting in an increase in correspondence. These developments meant that the small High Street post office was inadequate, and it was replaced by a new three-storey, red-brick and ragstone building in Railway Street in 1902.

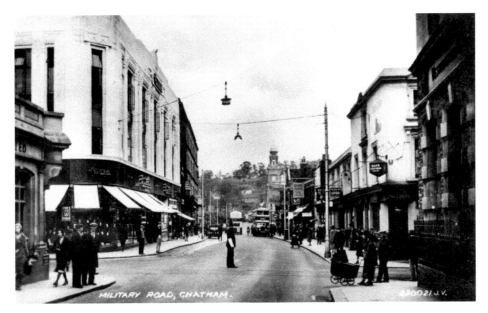

At the Crossroads

Four buildings dominate the junction where Railway Street and Military Road bisect the High Street. The two banks at the bottom of Railway Street still stand, but the Red Lion pub at the corner of Military Road and High Street is long gone. The large Portland stone building dates from 1933 and was occupied by Burton the tailor. The building now houses the Halifax Bank.

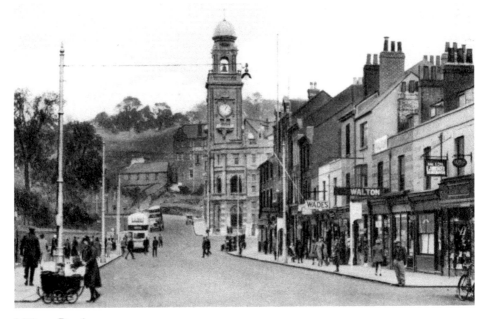

Military Road

This road was built to link Rome Lane with the fortifications surrounding the dockyard. The thoroughfare belonged to the government rather than the parish. Symbolically asserting their right, the military closed the road to the public one day each year. This unpopular state of affairs ended in the late 1870s, when the War Department gave the road to the Chatham Board of Health.

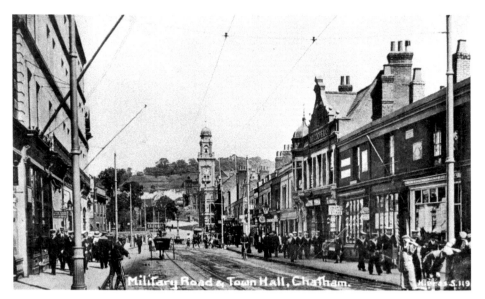

Military Road Continued

The Royal Navy provides a strong presence in this picture. The Welcome Home is on the left, while the Two Brothers public house and the adjoining Ind Coope offices occupy the taller buildings on the right. Next to them are Ernest Vincent, confectioner, and Mrs Chenery, hairdresser. Nearest to the camera are dining rooms belonging to Alfred Smith.

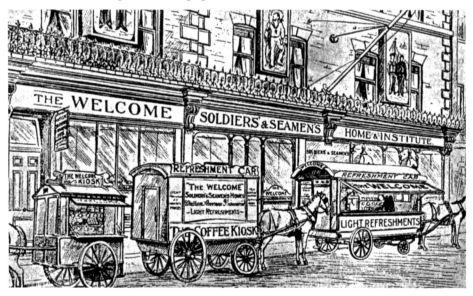

Welcome Home

In the 1870s, the Wesleyan chaplain to the Chatham garrison was horrified at the drunkenness and immorality in the town. He undertook a fundraising tour to finance the building of a respectable alternative to Chatham's pubs and brothels. One donor, John Hamilton of Hull, purchased two unoccupied houses in Military Road, which were converted into premises for respectable accommodation and recreation for servicemen. Built in memory of Hamilton's deceased daughter, they contained sleeping cubicles, games and classrooms, a library, bathrooms and a teetotal bar.

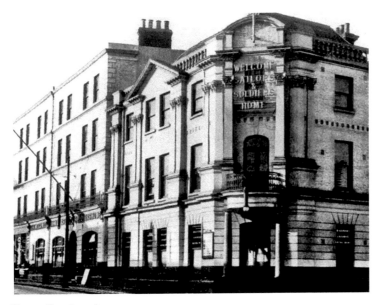

Welcome Home Continued

Through the years, the Welcome Home changed its name and underwent several extensions. The largest of these was the absorption of the neighbouring Reform Club in 1908. However, as barrack accommodation improved and rival institutions opened, the Home proved to be too large. In 1925, part of it was taken over by the Ministry of Labour as a Labour Exchange. The remaining part of the complex carried on until 1928, when it also closed. The building still stands but has had a variety of uses.

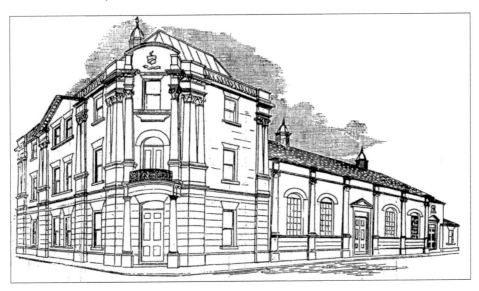

Chatham Reform Club

The Chatham Liberal and Radical parties opened this club in 1888 as a political meeting place and social venue. Built on the corner of Military Road and Medway Street, it was designed in a classical style. Inside were bars, games and committee rooms and lounges. On the Medway Street side was the Gladstone Hall, complete with stage and gallery. It accommodated about 500 people. The club proved to be far too large, and in 1908 was sold to the neighbouring Welcome Home.

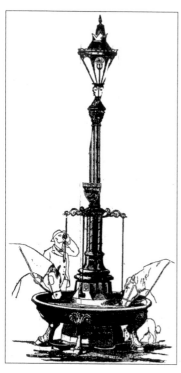

Military Road Memorial Fountain
The brewers Edward Winch & Sons presented this monument to the town to commemorate Queen Victoria's Golden Jubilee in 1887. It was made of iron and was surmounted with a lamp. Four goblets were provided for passers-by. Horses were catered for by a circular trough, below which were four dog troughs.

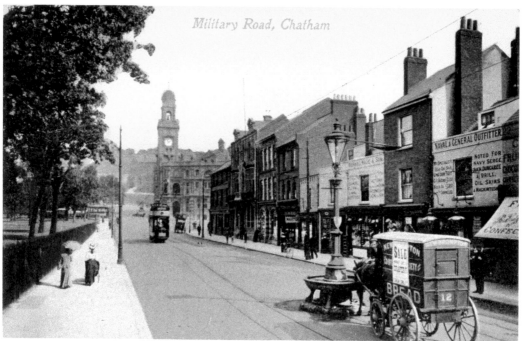

A Traffic Hazard
Even in 1887 there were complaints that the fountain caused an obstruction, and when trams were introduced, the rails had to be diverted around it. The fountain was dismantled in the face of increasing motor traffic in the 1920s.

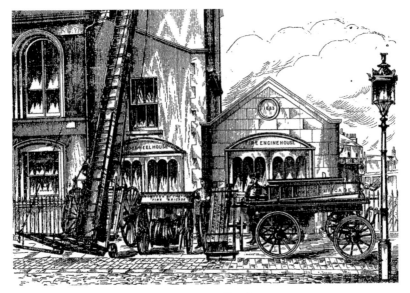

Chatham Volunteer Fire Brigade Station, Military Road
The original hose reel station adjoined the Board of Health building in Military Road. In 1885, a new fire engine was purchased and an engine house constructed to store it. This gave the fire brigade premises with a total frontage of 27 feet. The new building is on the right of the picture, with the hose reel station and Board of Health offices to the left. In 1902, new premises built under the New Road viaduct superseded it.

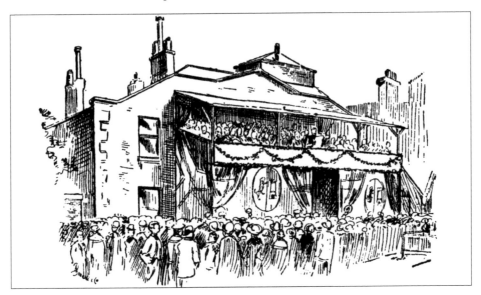

Proclaiming the Charter of Incorporation 1890
Chatham became an incorporated borough in 1890. The Charter of Incorporation was collected from London and then was carried around Chatham in a carriage full of dignitaries on 10 December. The Board of Health building in Military Road was covered with a two-storey tented pavilion from which the Charter was read. A disaster was averted when elements of the crowd attempted to enter the board's offices to escape the cold. The pavilion swayed alarmingly until the police cleared the crowd.

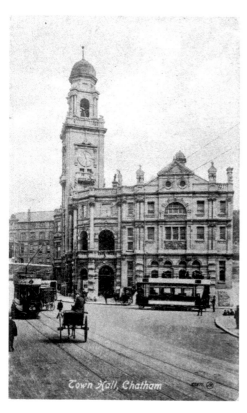

Town Hall, Chatham

Chatham Town Hall
Despite becoming an incorporated borough in
1890, Chatham waited a further ten years for its
own town hall. The building was opened by the
Earl of Rosebery in January 1900. Designed in
Italianate style by George Bond, it was largely
built of Portland and Bath stone, complete with a
tower containing a three-faced striking clock.
Four figures representing Justice, Britannia,
Agriculture and Music surmounted the western
and south-western sides.

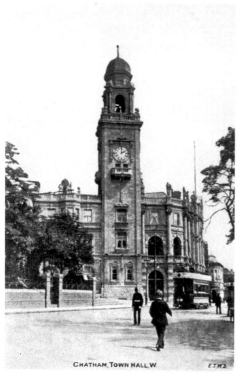

CHATHAM. TOWN HALL. W. E.T.W.D.

Chatham Town Hall Continued
The ground floor contained the offices of
municipal officials. A white marble staircase
supported by polished granite pillars took the
visitor to a colonnade, at one end of which was
a balcony overlooking Military Road. A large
ballroom was decorated in cream, gold, terracotta
and grey. The council chamber was surrounded by
a public gallery. There were telephones in all rooms
and the building was lit with electricity. It is now
used as a theatre.

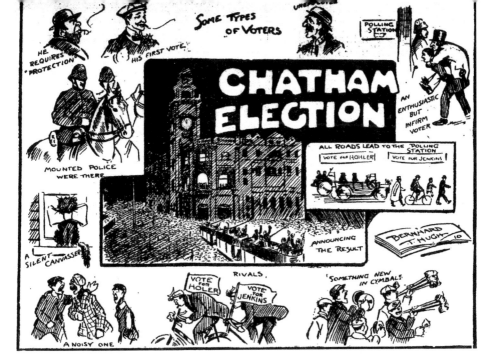

Chatham Divided (1910)

This cartoon reflects the divisions in the Chatham constituency during the general election of January 1910. The sitting Labour MP John Jenkins was defeated by the Conservative Gerald Hohler. Mr Hohler went on to hold the seat after a second election took place later in the year.

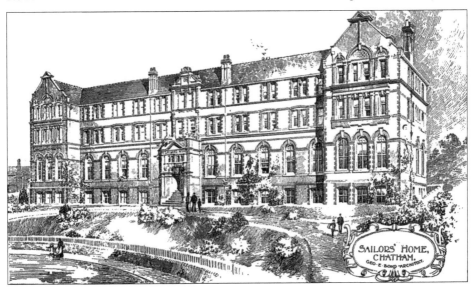

Royal Sailors' Home – Plans of 1902

The Royal Naval Barracks provided accommodation for sailors permanently stationed in Chatham. However, there was still a need for decent accommodation and leisure facilities for petty officers and seamen from ships temporarily in the dockyard. The Welcome Home and other facilities existed but were sectarian and teetotal. The Royal Sailors' Home was built with money from the Admiralty and the Naval Canteen Fund. The War Office donated land behind the town hall. George Bond's grandiose plans envisaged a building capable of accommodating 500 men.

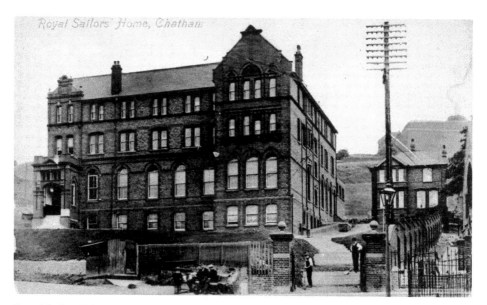

Royal Sailors' Home – The Reality
As opened in 1902, the three-storey building could house fifty-two men. The usual bathrooms, reading, games and dining rooms and large bar were provided. A separate residence for the manager was also constructed. However, Bond's plans were never fully realised. The Navy was contracting and money was short. Bombed in 1942, it closed for refurbishment in 1949, and reopened in 1951. By now it could accommodate 120 men, but was only ever a third full. It closed in January 1958.

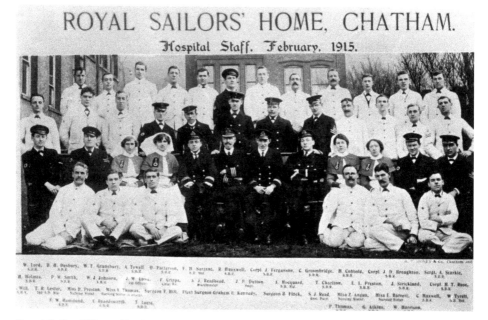

Royal Sailors' Home During the First World War
Like other buildings in Chatham, such as the Welcome Home and the Volunteer Drill Hall, the Royal Sailors' Home was converted into a temporary hospital during the First World War. This is the staff of the hospital during the early stages of the war.

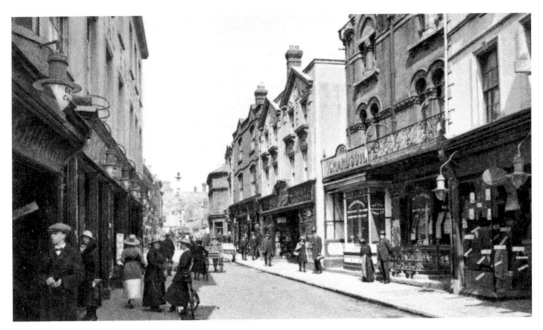

Start of the 'Golden Mile'
The central section of the High Street was traditionally home to the more important shops. This view is looking towards Military Road. On the left is George Church's Royal Emporium. Opposite is the Little George public house and Richardson's pork butchers. Beyond them are the premises of Boots the Chemist.

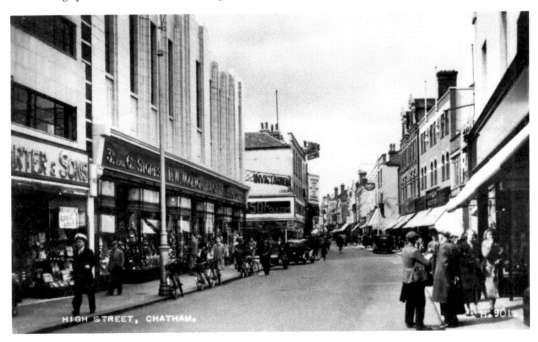

Further Along the 'Golden Mile'
The new Art Deco Woolworths store, dating from 1936, dominates this pre-war scene. The 50/- Tailors beyond it was built on the site of George Church's Commerce House. Between them, tucked away in Fullager's Yard, was the Invicta Cinema, which closed in 1939.

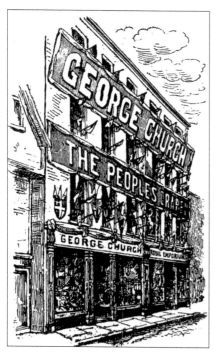

Royal Emporium, High Street
In 1879, Alfred Semark sold the Royal Emporium drapery to George Church, who retained the business's name. Here, the store is decorated for the local Agricultural Show in June 1890. George Church also owned Commerce House in the High Street. After his death in 1917, his family continued to run the business. They sold the Royal Emporium site to Marks & Spencer in 1934.

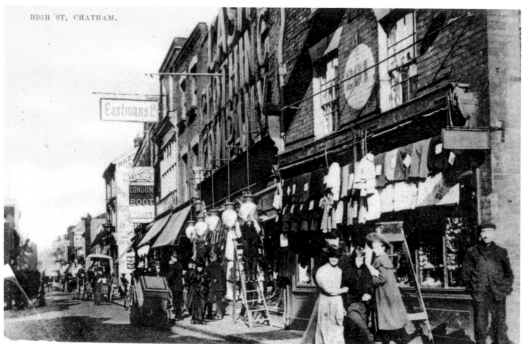

'Golden Mile' Continued
The Edwardians had a wide range of goods to choose from in this part of the High Street. Looking west from the corner of Batchelor Street, the premises of Joseph McCrea, pawnbroker, lies at No. 261. Among the shops beyond may be seen the Cash Clothing Company, Eastman's the butchers and Arthur Pash, bootmaker.

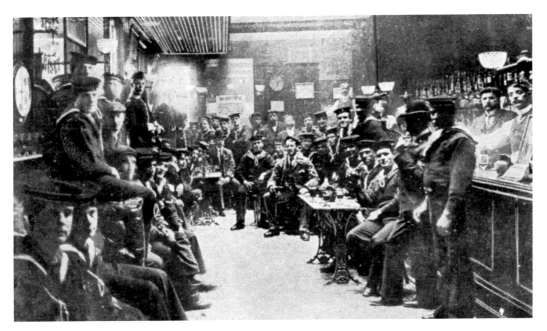

Long Bar
This is the interior of the United Service Hotel, also known as the Long Bar, in the High Street. Naval clientele clutch their pints while stereotypical Edwardian bar staff pose for the camera. These premises were demolished in 1936 to make way for a large Woolworths store.

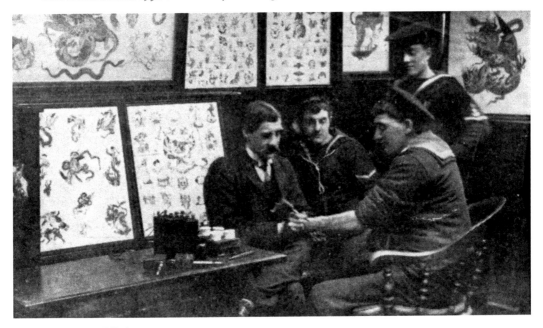

An Artist at Work
'Professor' William Mansford made his living as a tattoo artist in the Long Bar. In 1911, Mansford, his wife and two children lived in three rooms at No. 12 Clover Street, indicating that his income from tattooing was fairly modest. He continued his tattooing work even after opening a cycle and radio shop.

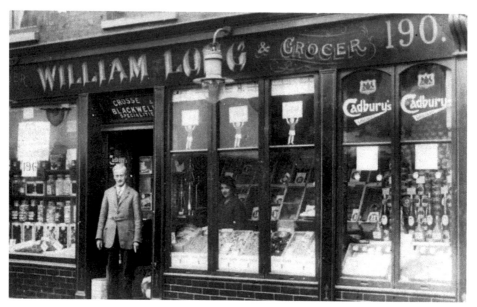

William Long's Grocer's Shop

Another business that gave way to the new Woolworths store in 1936 was William Long's grocery. His premises lay adjacent to the United Service Hotel. Here, Mr Long and his staff have their goods attractively displayed, tempting the passer-by to enter the shop and make a purchase.

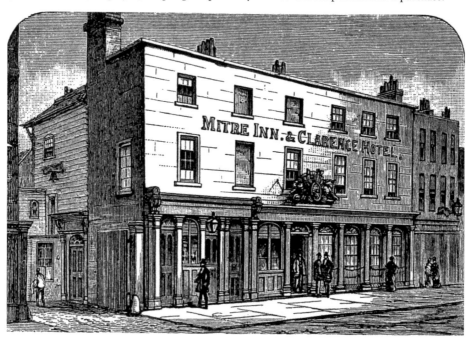

Mitre Hotel

The Mitre Inn – or the Mitre Inn and Clarence Hotel, as it was renamed after the future King George IV stayed there – was a longstanding Chatham High Street landmark. Admiral Lord Nelson was a guest there on several occasions, and the Dickens family were friendly with the proprietor. The Mitre closed in 1934, the site being purchased by British Home Stores (BHS).

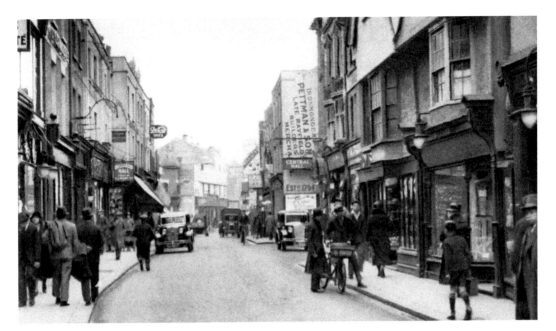

Pre-War View of the 'Golden Mile'

The car on the right is parked outside the Methodist Central Hall. Next door and nearer to the camera was Paines the outfitter's. On the opposite side of the road, the Duchess of Edinburgh public house is on the extreme left, with Chatham Billiard Hall and Dolcis shoe shop in the distance.

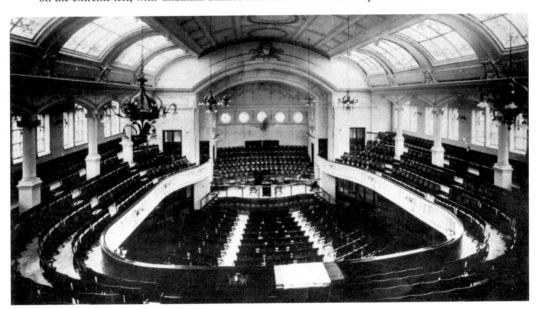

Wesleyan Mission ('Central Hall') High Street

The Wesleyan Methodists had no place of worship in Chatham in the early twentieth century. Thanks to the Revd Richard Hall, a former bank was acquired in 1905 and services were held there until its demolition. In 1908, a large mission hall was opened on the site complete with schoolrooms, gallery and crush hall. If the latter was opened, more than 1,500 people could be accommodated. The hall was sold to Chatham Council for a theatre in 1966.

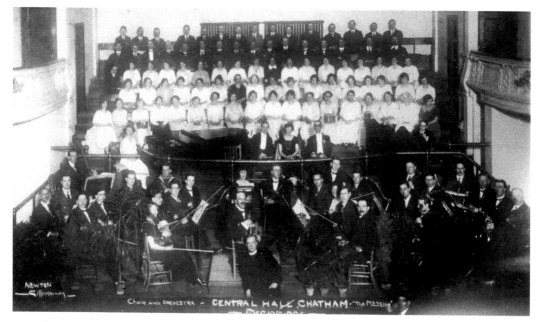

Central Hall Concert

The choir and orchestra of the Methodist Central Hall pose on stage prior to their performance of Handel's *Messiah* on 17 December 1924. The critics singled out the tenor, Miller Richards, for special praise. The conductor was F. W. Ralph, and the clergyman seated at the front was probably the Revd Richard Hall.

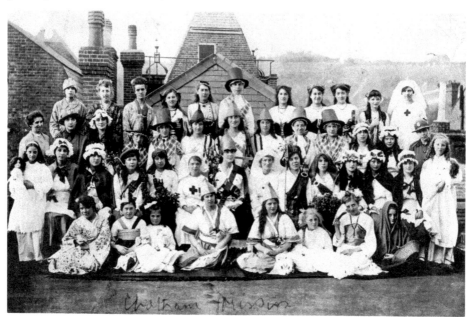

Performers at the Central Hall

One can only speculate as to the date and occasion of this image. Taken on the roof of the Central Hall with the Great Lines in the background, this photograph shows a group of children and young adults in various national costumes. That of Wales appears to figure prominently.

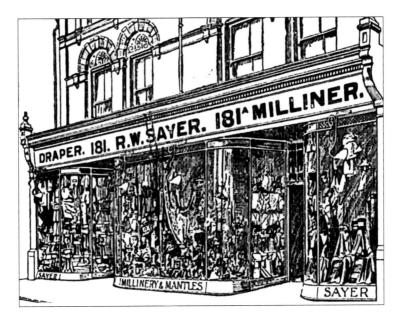

Sayer's Drapery
Situated at No. 181 High Street in the middle of the 'Golden Mile', Sayer's drapery was in existence for about thirty years, a few shops west of the Fair Row corner. By 1930, a large Co-operative Society drapery had taken over the site.

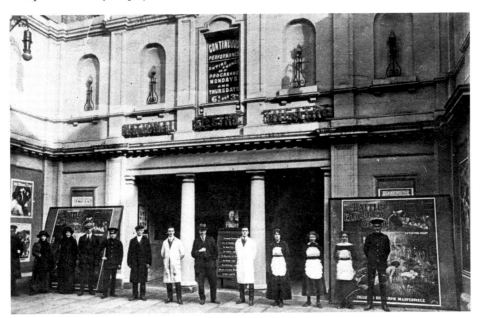

National Electric Theatre
This was Chatham's second cinema. When it opened in April 1911, it could accommodate just over 600 patrons; a further 200 were catered for by a balcony, which was added in 1914. In 1928, it was taken over by Gaumont British, who used it for second or third run films, but the so-called 'super cinemas' of the 1930s made the National look inferior. It closed in 1951 and has been a fashion store ever since.

Navy House, Clover Street

A fundraising committee of naval officers and clergy purchased a house in Clover Street in 1901. Originally, the Navy House had four bedrooms with eighteen beds and reading, dining and games rooms for Royal Naval seamen. It expanded into a neighbouring property and by 1912 it contained eighty-one sleeping cubicles. As the Navy contracted, it was opened to non-Naval personnel. After the Second World War, demand for the facility fell. Half of the building was sold to the Brown Brothers Engineers in 1960. The rest closed in 1969.

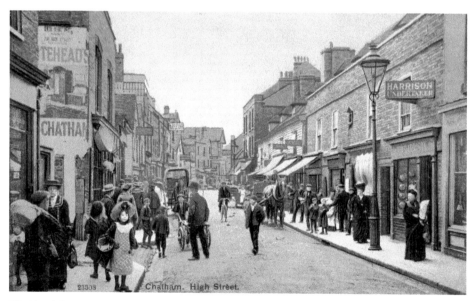

'Golden Mile' Looking West

Two businesses are worth noting in this photograph of the High Street's central section. On the left is an advertisement for Whitehead's furniture shop, which was situated further along the street. The undertaker's business on the right was started by John Harrison in the 1830s. It was still in the family when this picture was taken in the Edwardian period.

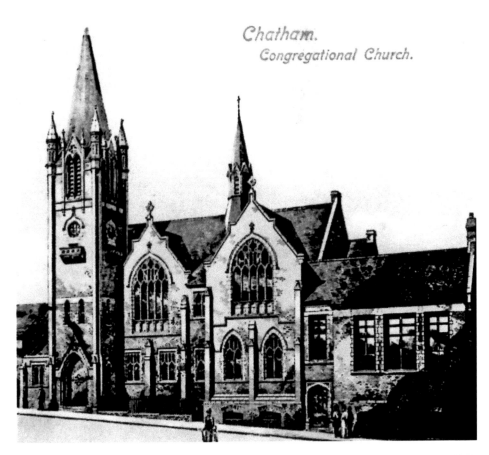

Above: Ebenezer Congregational Church
A Congregationalist place of worship
probably existed on this site since the
seventeenth century. This building, which
today is minus its spire, replaced the
previous one that burnt down in 1890. At
the time of writing, it is used by the Church
of England.

Right: Reverend Joseph Slatterie
A turning point for the Ebenezer church
was in 1794, when the Irish-born Slatterie
became pastor. Under his pastorate, a new
brick building was constructed in 1810 to
replace the previous wooden one. He also
created branches of the Ebenezer in Strood,
Brompton, Rochester, Higham, Snodland,
Bredhurst, and on Chatham Hill, among
other places. Slatterie became ill in 1834
and died in 1838.

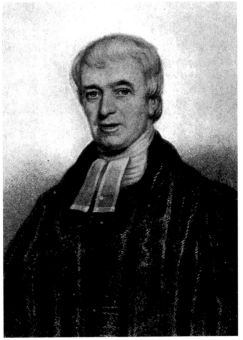

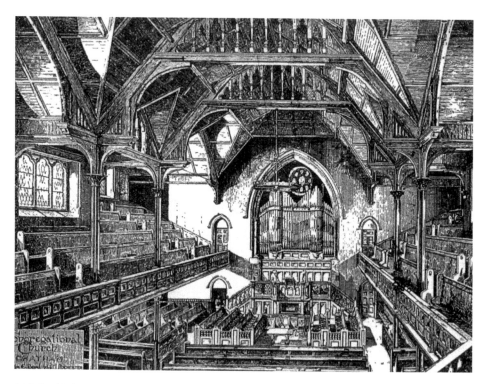

Above: Inside the Ebenezer Church
In 1891, the Ebenezer church was rebuilt to plans designed by George Bond. Its imposing structure led some locals to affectionately refer to it as Chatham's cathedral. Many of the town's most influential citizens, particularly tradesmen such as George Church, worshipped there.

Left: High Street, East End
We are looking at a block of shops bounded by two public houses – the British Queen and the Little Crown. This postcard was published by the stationer Richard Baldwin, whose premises were adjacent to the British Queen. Baldwin was a Leading Man of Labourers in the dockyard. In 1907, he retired after forty-six years' service. His daughters had managed the shop while he was working.

Bible Christian Chapel, Union Street

As the dockyard attracted workers from all over Britain, the Medway Towns were home to many religious denominations. One such was the Bible Christians, a Methodist sect from the West Country, which sent missionaries to Medway in the 1820s.
The Chatham chapel opened in 1829, and other congregations were formed in Luton, Gillingham and Rainham. The decline of nonconformism made the building redundant and it closed in 1954. The chapel, along with the rest of Union Street was demolished for road improvements in the 1970s.

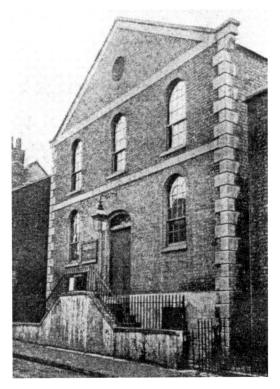

Imperial Picture Palace (IPP)

The East End of Chatham got its own cinema just before the First World War. Shops and cottages were cleared and the IPP, designed by George Bond, was opened in 1914. It was the largest cinema in Chatham, accommodating 750 patrons. In 1927, the IPP was refurbished and renamed The Regent by its new owners, Associated British Cinemas (ABC). Ten years later the building was demolished. ABC built a new super cinema on the site, also known as The Regent (later renamed the ABC). It closed in 2002.

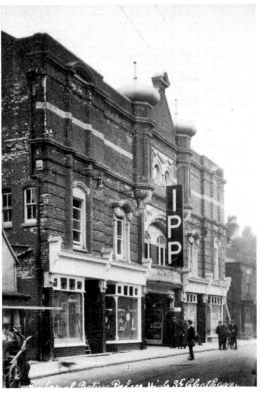

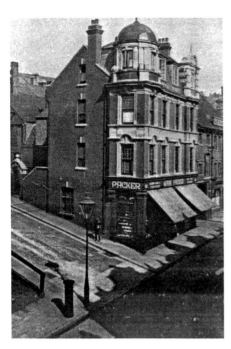

Mark Packer's Bakers
The extensive premises of Mark Packer were situated at the corner of the High Street and Institute Road. Dating from the Edwardian period, the bakery belonged to Mark Packer senior and then to his son, also named Mark. The business merged with Jasper & Son (Betabake) in 1959, and the premises were taken over by C. J. Howard, the builder's. A martial arts centre now occupies part of the building.

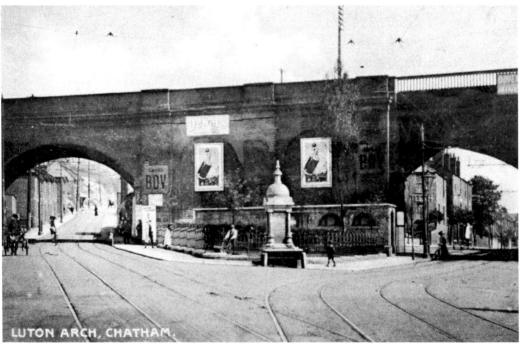

'Fancy, People Up There!'
Five-year-old Godfrey Catt watched the Luton Arches and their embankment being constructed. 'It was a great day for me and my little pals when we saw the first passenger train pass over that bridge and whistle its way into the Lines Tunnel. "Fancy, people up there!" we cried.' The Driver Fountain in front of the Arches refreshed horses and people. It was installed by Councillor Driver to honour his late father in 1899. The fountain now rests in Chatham cemetery.

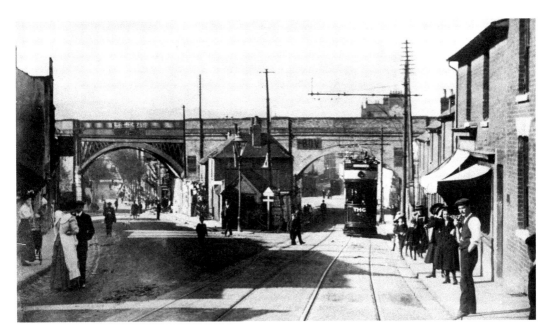

Luton Arches

The arches that took the East Kent Railway over the complicated road junction where New Road, High Street, Chatham Hill, Luton Road and Magpie Hall Road meet is an iconic Chatham structure, dating from 1857. While the Arches themselves are largely unchanged today, the houses abutting the central portion in this picture have now gone. Notice the pedestrians standing and walking in the road on the left, a scene that could not be repeated today.

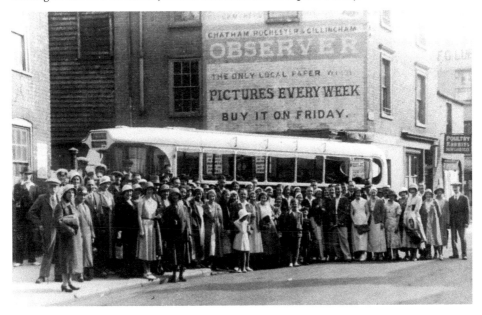

Chatham Observer Works

This coach party was photographed outside the *Chatham Observer* printing works in Fair Row some time in the 1920s. The *Observer* began its life in 1870, and ceased publication in 1968, when it was replaced by the now defunct *Evening Post*.

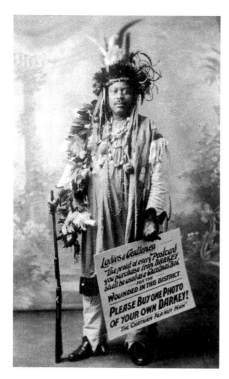

Stephen Martin, the Baked Peanut Man
Dressed in 'African' robes, Stephen Martin was a common sight in Chatham High Street before and during the First World War. Born in Jamaica, Martin spent much of his life in the USA before arriving in Chatham. He lived off The Brook in Fair Row, and his pitch was in the High Street on the corner of Globe Lane. In this picture, the peanut vendor is raising funds to help the wounded in the First World War.

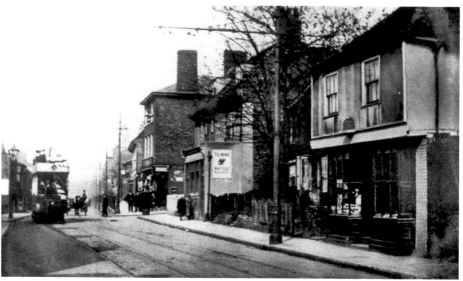

The Brook
For many years, The Brook and the streets that surrounded it constituted one of the poorest areas of Chatham, a resort of thieves and prostitutes. However, it had started on the long road to respectability by the time this Edwardian photograph was taken. The town hall had opened at one end, and the council's depot at the other. Some of its notorious pubs had closed, and the would-be respectable Gordon Chambers lodging house had opened as a rival to the existing dens of iniquity. The tram in this picture was passing the Lord Nelson beer house near the junction with King Street. Beyond this was Arthur Parsons' pawnbroker's shop and the terraced stretch known as Smithfield Bank.

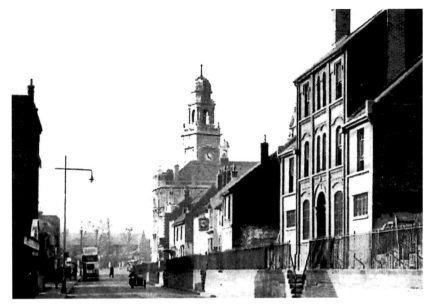

Gordon Chambers, The Brook

Many of the lodging houses on The Brook were seedy and disreputable. Gordon Chambers was designed by George Bond and opened by Isaac Morris of Gravesend in 1889. It was an attempt to provide comfortable and respectable accommodation for single men. The results were mixed to say the least. The building itself survived into the 1960s.

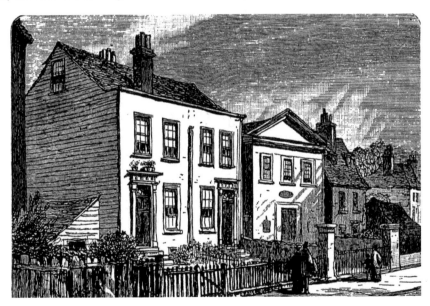

No. 18 St Mary's Place, The Brook

For financial reasons, the Dickens family moved from Ordnance Terrace to this address in 1820. At this point, The Brook was not yet the notorious area it later became. The Dickens' house consisted of six rooms on three storeys, with gardens at the front and rear. The family moved to London in 1822. In 1941, the house, which by then was a lodging house, was demolished along with Providence chapel, seen to the right of the picture.

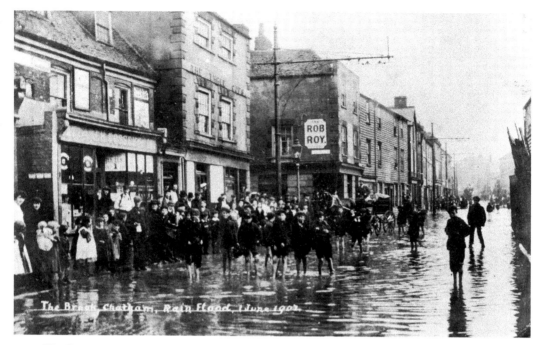

The Brook in Flood, 1907

This was probably the most notorious Chatham thoroughfare, containing many low pubs and brothels. The Rob Roy and the Three Cups on either corner of Queen Street may be seen in the centre of the picture. Being at the foot of the Great Lines and the lowest point of Chatham, the Brook was prone to flooding. This scene was captured after a particularly bad storm in June 1907, when torrents of rainwater rushed down Slickett's Hill, Queen and King Streets.

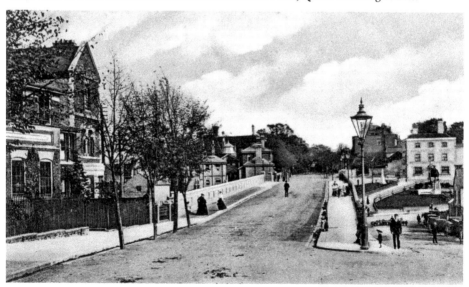

New Road/New Cut Junction

Here we are approaching the New Road viaduct from the west. The Gibraltar Hotel is on the right, beyond which is Nevill House. Notice the flock of sheep being driven up New Cut, perhaps on their way to graze at Fort Pitt Fields.

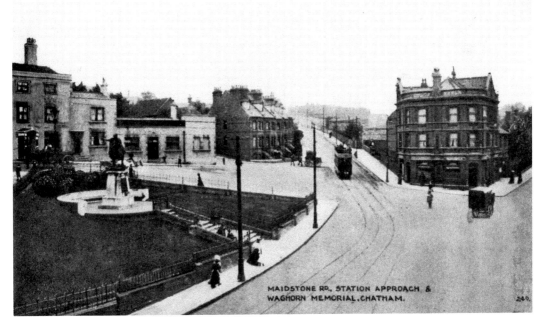

MAIDSTONE RD., STATION APPROACH & WAGHORN MEMORIAL, CHATHAM.

Towards Maidstone

This view southwards from the New Road viaduct shows the Alexandra Hotel on the right. The Waghorn memorial and the Gibraltar Hotel behind it may be seen on the left. The tram is making the long climb up the Maidstone Road towards Chatham cemetery.

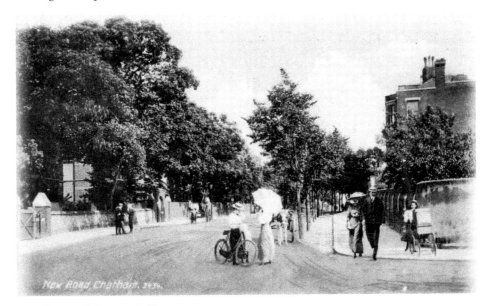

New Road Chatham.

New Road – A Summer's Day

This is an Edwardian view at the eastern end of the New Road viaduct. Nevill House is on the right, the garden of which is now a petrol station. The rectories of St Mary's and St John's are on the opposite side of the road.

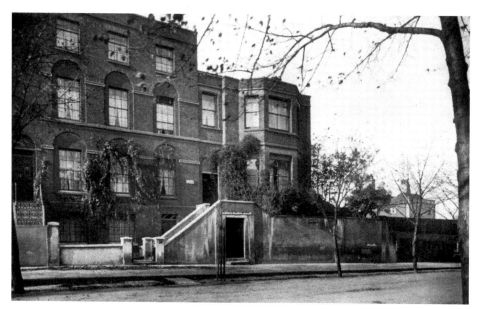

Nevill House

This imposing building is still to be found at the western end of the Georgian Gibraltar Terrace. It was a private residence until shortly before the First World War. Nevill House remained a nursing home through the interwar period. It had been converted into flats by 1950.

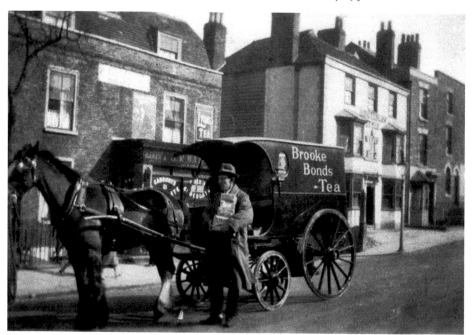

New Road – A Major Thoroughfare

Probably taken in the 1920s, this photograph shows Charles Joyce, a tea salesman for Brook Bonds. He had been delivering tea to the shop on the corner of James Street, seen behind his van. On the opposite corner is the Lord Duncan pub, the only building in this photograph that survives today.

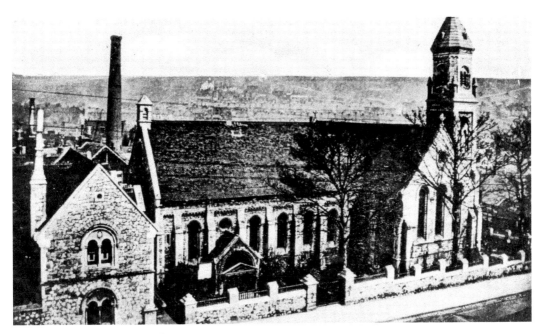

St Paul's Church, New Road

In 1854, the parish of St Paul's was created from parts of Chatham and Gillingham parishes. The church was built next to the New Road toll gate, which was dismantled in 1871. The church was constructed of Kentish ragstone and had a one-belled tower. The chimney of the Kent Electric Power station in Whittaker Street may be seen on the left. St Paul's was demolished in 1970.

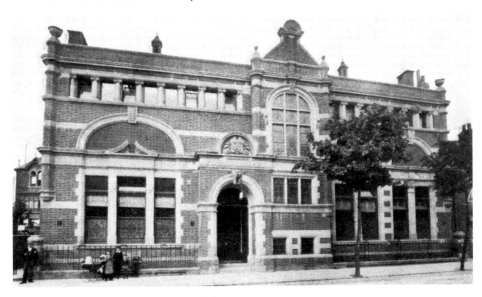

Chatham Free Library, New Road (1903)

This was different from previous libraries as it was run by Chatham Council and was free to use. It was funded by a grant of £4,500 from the Carnegie Foundation and a penny rate to finance running costs. Out of its original stock, 2,000 books were provided by the Ebenezer Congregational church. This red-brick building designed by George Bond served the community until 1971, when it was superseded by a prefabricated structure on Chatham Riverside.

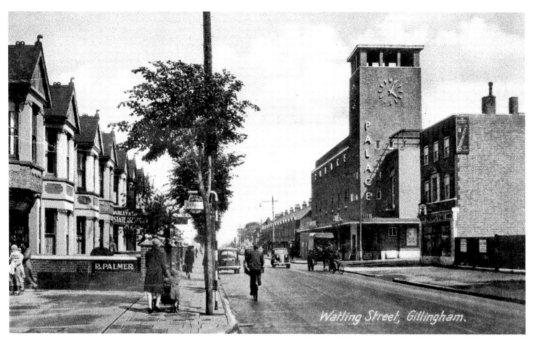

Watling Street

The boundary between Chatham and Gillingham ran down the middle of Watling Street at this point. On the left, Palmer's Ironmongers and Darley's Estate Agents are on the Gillingham side, with the Palace Cinema and an off-licence lying within Chatham.

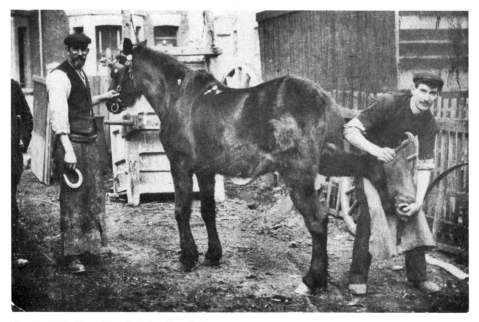

Blacksmith's Premises, Cobden Road, Luton

In the days when motor vehicles were rare and horse-drawn transport reigned supreme, blacksmiths were a common sight. James Snowden, a blacksmith and wheelwright, had his shop in Cobden Road from the late 1880s until his death at the age of sixty-five in 1916.

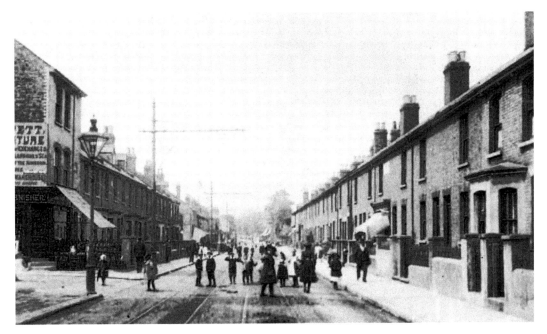

Luton Road

Until the late nineteenth century, Luton Road ran through brickfields and farmland. As Chatham's population rose, the road was filled with housing. This photograph was taken at the junction with Connaught Road. The scene itself remains remarkably unchanged, although the tramlines have gone and children no longer congregate in the middle of the road.

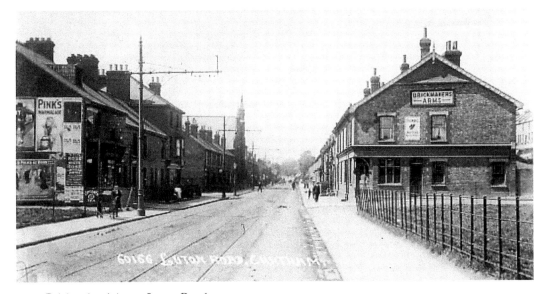

Brickmakers' Arms, Luton Road

This pub's name reflects the fact that much of the opposite side of the road was brickfields until the 1880s. The War Department owned both sides of the road nearest to the camera. There had been plans to link Fort Luton to the forts in Gillingham by railway. It would have been taken over Luton Road at this point by a viaduct. The footings were actually dug, but the project was eventually abandoned.

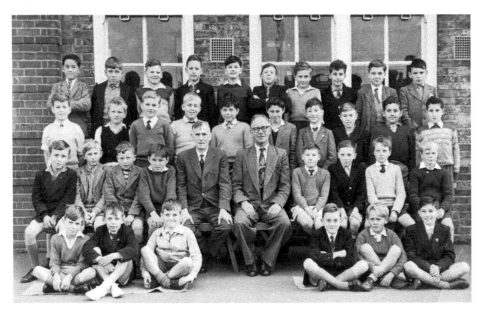

Pupils at Luton Boys' Primary School, 1961

When this photograph was taken, the narrow strip of former War Department land between Alexandra Road and Luton Road contained three schools. The boys' school was in the middle between the infants' school and the girls' primary. The teacher of this fourth-year class, Mr Steer, is on the left, with the headteacher, Mr Nye, on the right.

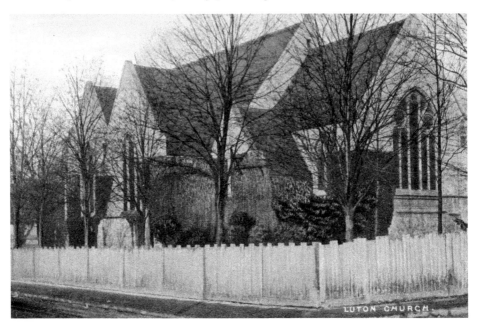

Luton Church

Luton did not become a parish in its own right until 1852. The church shown here was consecrated in 1885. It replaced the original building that had been built in 1842. A tower and a spire were added in 1929. The church was demolished in 1982 due to subsidence, its replacement serving both Anglicans and Methodists.

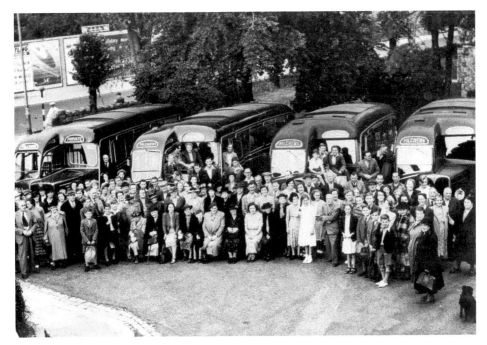

Coach Party, Luton 1950s
This group, pictured outside Luton church, consisted of Luton residents. They are about to embark upon a coach trip, probably organised by the church. Their carrier is Pilcher's Coaches – a company that went back to the mid-nineteenth century. Its depot was on the nearby Beacon Road.

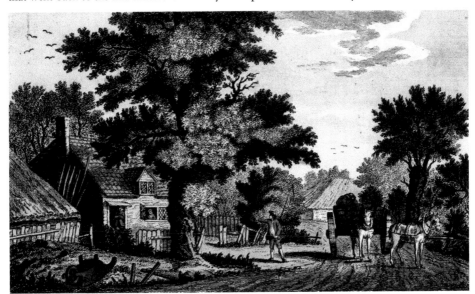

Luton in the Eighteenth Century
This print dates from 1770 and forms part of 'Twelve Views in Kent and Surry, drawn from Nature' by John Cleveley the Younger. It is impossible to pinpoint the exact location of this view. However, one suggestion is that it is somewhere on today's Capstone Road. The artist, like his father, is better known for his naval dockyard scenes.

Luton Village

This Edwardian view of Luton is recognisable even today, as the buildings in the background still stand. Tramcars linking Luton to the dockyard terminated here. The licensee of the Hen & Chickens pub at that time was William Pilcher, a member of the locally famous coach-owning family.

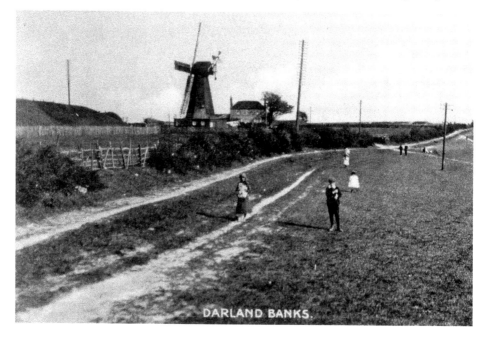

Serving the Community – Darland Banks

This is a view of Star Mill from the western end of the Darland Banks. At the top left is the reservoir of the Brompton, Chatham & Gillingham Water Company, the contents of which were pumped up from the Luton Valley below.

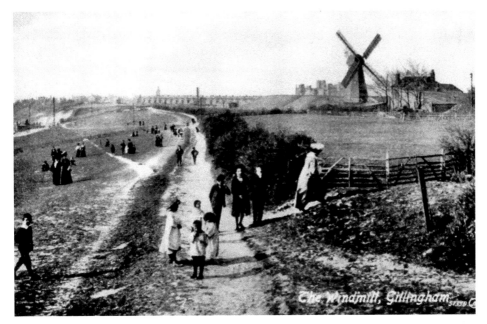

Taking the Air on the Darland Banks

Despite the caption, this Edwardian photograph was taken at the Chatham end of the Darland Banks. The woman is probably walking towards a nearby stile. Star Mill and the miller's house may be seen behind her. In the background, one may glimpse the Jezreel's Tower. The Darland Banks were a source of good, fresh air and clearly very popular.

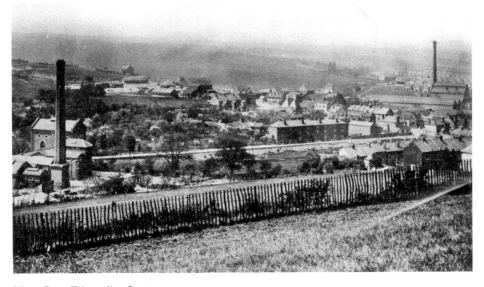

View Over Edwardian Luton

The original village of Luton was still semi-rural when this photograph was taken. Stone Cross Farm lay in Street End Road, which runs toward the top left corner of the image. There were oast houses in the village itself. The chimney on the left belonged to the Luton Waterworks; the one on the right marked the site of the tramway's generating house. The block of houses in the middle were in Nelson Terrace.

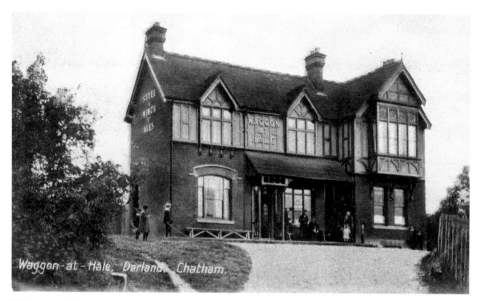

Waggon at Hale

This pub was once at the centre of Hale, a small community south-east of Luton village. Its labouring residents were involved in brickmaking and agriculture. The community has gone, but the Waggon remains. The current structure was built in the late 1880s and designed by George Bond. It replaced an older building that had stood on the same site. In the Victorian era the nearby Ash Tree Lane was named Waggon Lane.

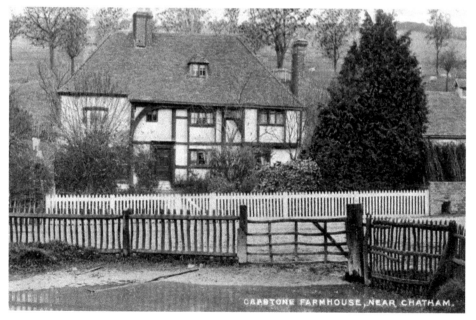

Capstone Farm House

It is thought that this building dates from the mid-fifteenth century. The photograph was taken from the farm itself, which lies opposite. Chatham Council purchased the farm in 1928. It was held by various tenant farmers until 1984, when the council transformed it into a country park. The farmhouse itself is in private hands.

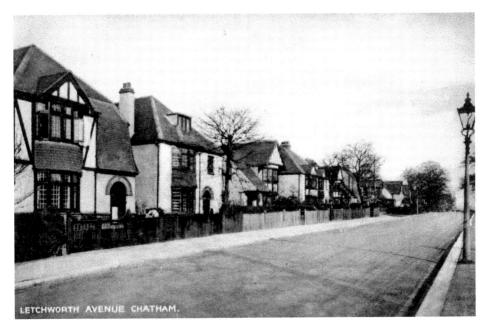

Letchworth Avenue

Letchworth in Hertfordshire was the first of the pre-First World War garden cities. The idea of these new towns was to use zoning in order to separate industrial areas from residential, and to create a green environment for the residents. If Letchworth provided the inspiration for such a district to the south of Chatham, it was an idea that failed.

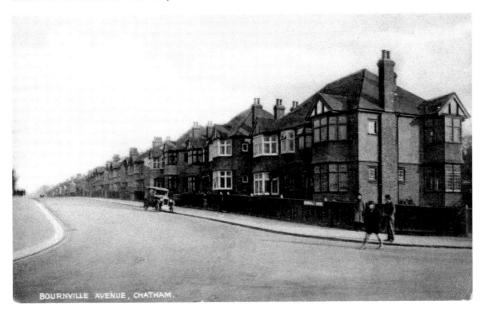

Bournville Avenue

Chatham extended southwards between the wars. Bournville Avenue, named after the model village for Cadbury workers in Birmingham, was part of the development that also included Horsted and Letchworth Avenues. They were built in the mock-Tudor style, which was so popular in the private estates of the period.

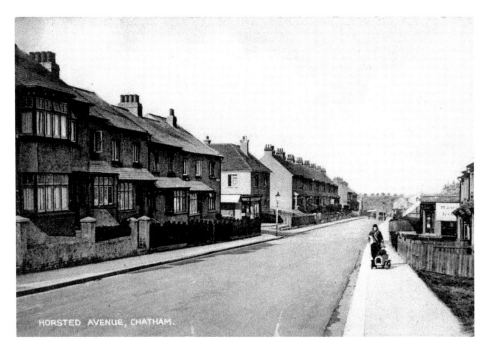

Horsted Avenue

This view looks from Elm Avenue towards Horsted Avenue. The image probably dates from the late 1920s when the houses were new. The subscription lending library of Alfred Marshall is on the right. Virtually the only car in sight belongs to the little boy peddling it towards us.

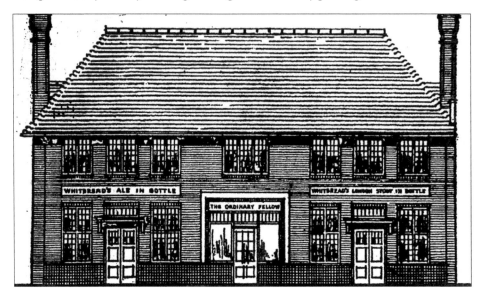

Ordinary Fellow

When the Brown Jug pub in Whittaker Street was demolished in 1937, its licence was transferred to the newly built Ordinary Fellow in Palmerston Road. The new pub's name originated from the time of the Silver Jubilee of 1935, when King George V referred to himself as an 'ordinary fellow'. Portraits of the deceased king were prominently displayed in both the saloon and public bars. The building is now divided into flats.

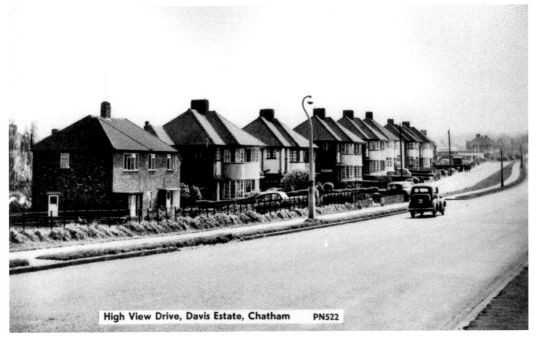

High View Drive, Davis Estate, Chatham PN522

Davis Estate – High View Drive
Situated near the boundary with Rochester, the Davis Estate was under construction when the
Second World War interrupted its growth. Building resumed in the 1950s. In this image, the car is
travelling on the main road towards Maidstone, and in the distance are some of the estate's shops.

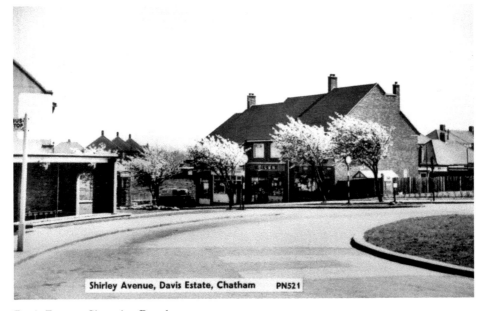

Shirley Avenue, Davis Estate, Chatham PN521

Davis Estate – Shopping Parade
One early and frequent complaint from residents of local council estates, such as Wayfield, was
that the area was devoid of shops. Those who planned this private estate avoided that criticism
and a variety of premises were provided in Shirley Avenue.

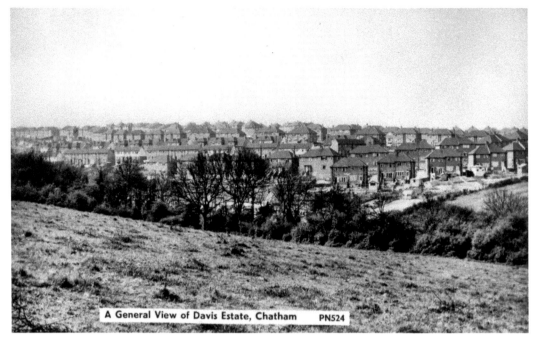

A General View of Davis Estate, Chatham PN524

Overview of the Davis Estate

The extent of the Davis Estate may be gauged from this scene. Many of the houses have garages and a few caravans may be seen – an indication that this picture was taken during the affluent 1950s.

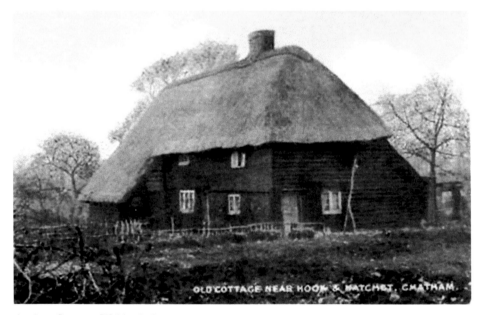

OLD COTTAGE NEAR HOOK & MATCHET, CHATHAM.

Ancient Cottage, Walderslade

Emphasising the original rural charm of this part of Chatham, this thatched building appears to be more substantial than the 'cottage' implied by the caption. The photograph was taken before the First World War, at a time when some Chatham residents were beginning to view Walderslade as an ideal weekend retreat.

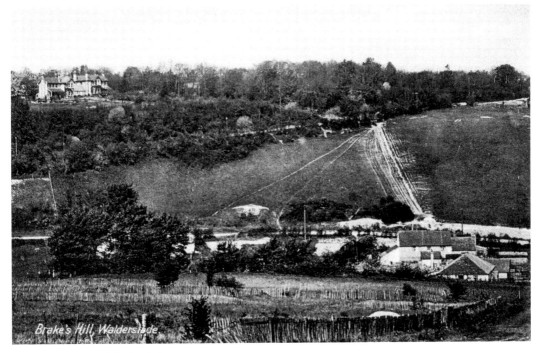

Brake's Hill, Walderslade

Henry Brake, a surveyor and auctioneer, purchased the 325-acre Walderslade Estate in 1899. He cut roads through it, laid on water and then divided it into plots, which he then resold. Cottage plots with substantial garden ground could be purchased for £10. Buyers could pay a 10 per cent deposit and pay the rest off at 2d per month at 5 per cent per annum interest.

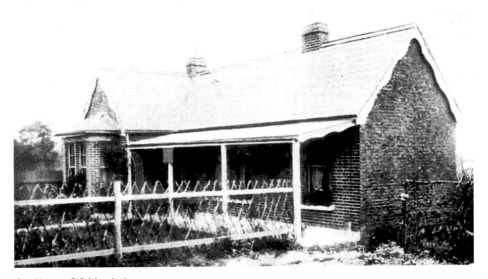

Cecilhurst, Walderslade

This bungalow was at the centre of a 6-acre farm, which was half arable and half woodland. Stables, pigsties and chicken coops added to the farming options. Intended for a part-time or amateur farmer, Cecilhurst had two reception rooms and three bedrooms. It was situated in Hook Road, later renamed Walderslade Road.

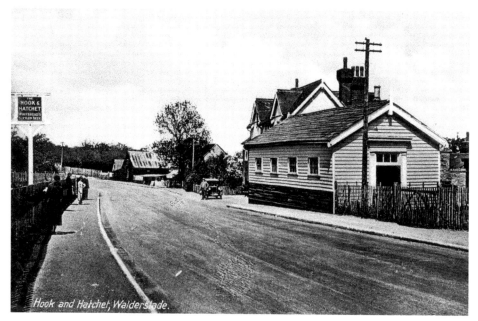

Hook and Hatchet, Walderslade

Hook and Hatchet, Walderslade

The car in this pre-war photograph is parked outside what was then known as the Hook and Hatchet pub in Walderslade Road. The long-established name of the premises reflected the tools used in the traditional occupations of this wooded area. By 1973, Walderslade had become urbanised, and the pub's name was changed to the Poacher's Pocket.

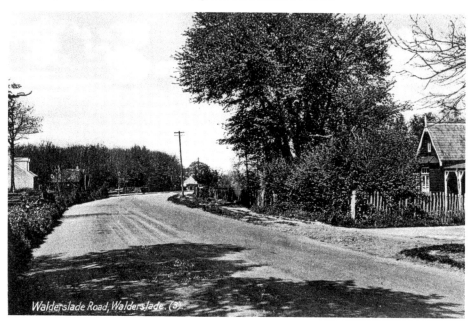

Walderslade Road, Walderslade. (3)

Walderslade Road

This ancient lane, developed by Henry Brake in the early twentieth century, was formerly known as Hook Road. One may see that it was still semi-rural before the Second World War. The area was completely transformed by private and public housing in the post-war period.

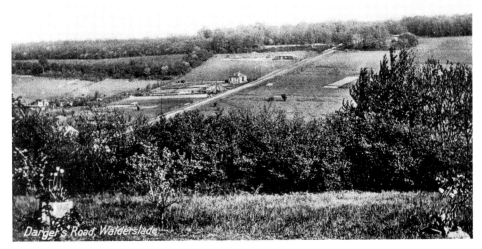

Dargets Road, Walderslade
This picturesque rural scene shows how wooded the Walderslade area once was. The steeply sloping Dargets Road is hardly developed in this pre-war photograph. Today, linking Albermarle Road with Princes Avenue, it is a major thoroughfare through the urbanised sprawl of the estate.

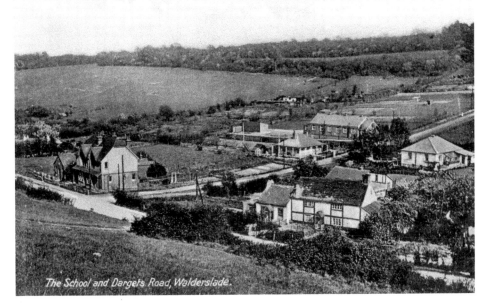

Dargets Road, Walderslade – Old and New
This is the bottom of Dargets Road, showing what existed in Walderslade before the Second World War. A house, dating at least from the eighteenth century, stands to the right. Beyond it is one of Henry Brake's bungalows from the turn of the century. The newly built school is on the hill. Next to the houses on the extreme left is the Wesleyan Mission, which opened in 1908.

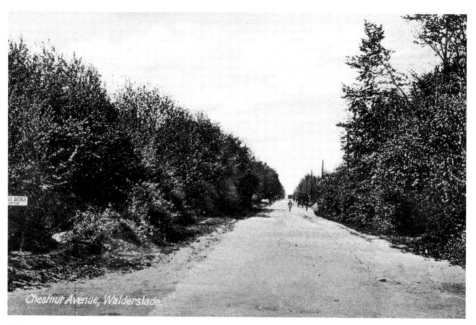

Chestnut Avenue, Walderslade

The name of this road indicates the previously wooded nature of Walderslade. It was created in 1902, and at first the houses were individually named – The Squirrels, The Ash, Twin Birches, and so on. Now there are hundreds of homes, identified merely by number.

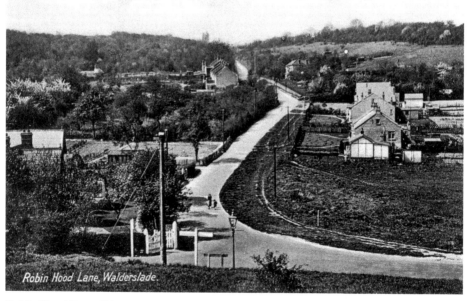

Robin Hood Lane, Walderslade

The steep hills that form a prominent feature of Walderslade may be appreciated in this photograph. There had been some development by the time this pre-war picture was taken, but one could still escape to there from Chatham's hustle and bustle. Walderslade's real transformation was yet to come.

Gravesend Through Time

Robert Turcan

This fascinating selection of photographs traces some of the many ways in which Gravesend has changed and developed over the last century.

978 1 84868 125 5
96 pages, full colour